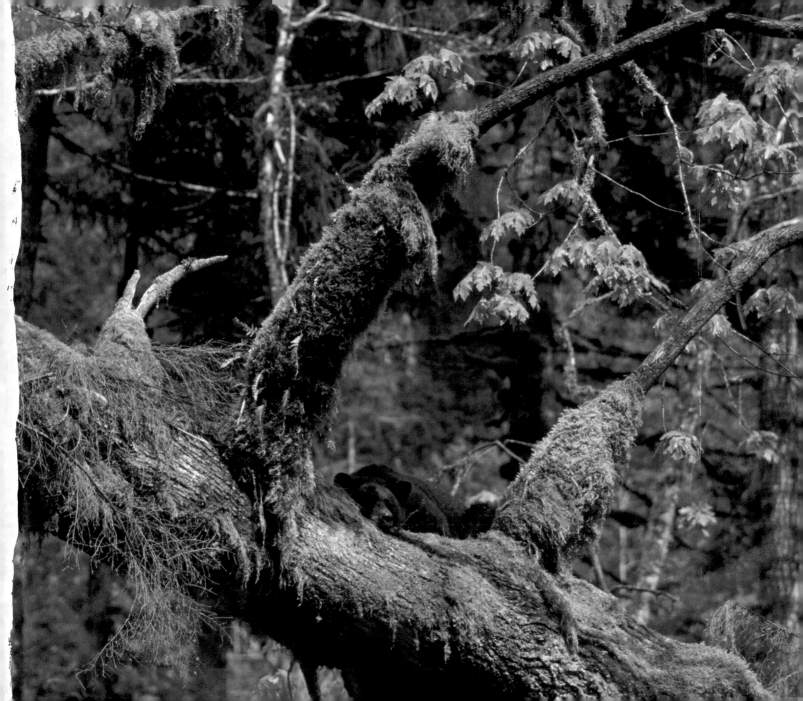

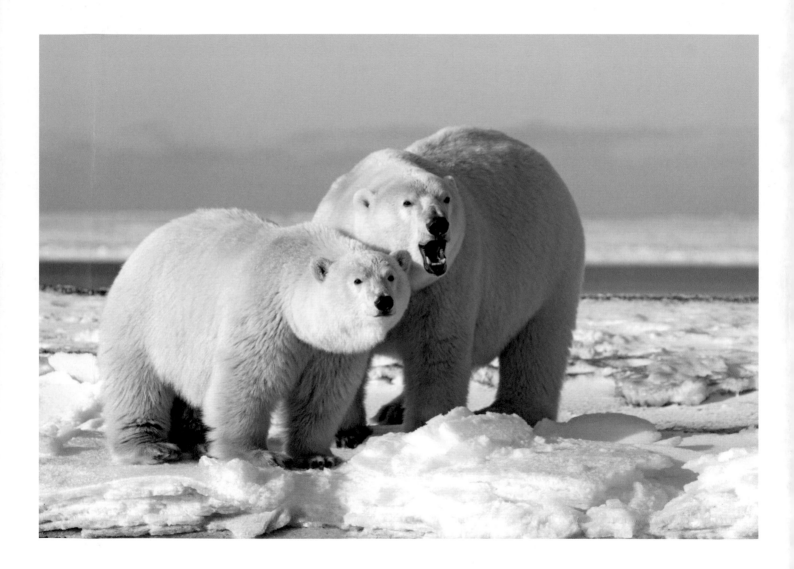

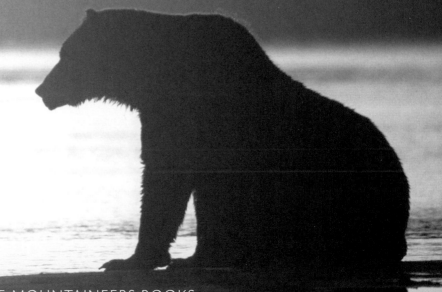

STEVEN KAZLOWSKI

BEAR COUNTRY

NORTH AMERICA'S GRIZZLY, BLACK, AND POLAR BEARS

THE MOUNTAINEERS BOOKS

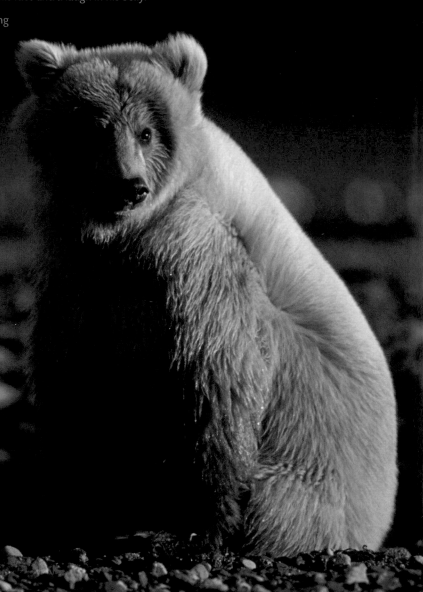

To Jack Kayotuk, my good buddy, who always has a big smile on his face and a laugh in his belly.

To Bruce Inglangasak, my other good buddy, for his understanding of traveling safely, his willingness to help me on many occasions, and his many long stories, which have made many months pass quickly over the years.

To Fred Kaleak, for his friendship and for sharing his love and his family's love for the polar bear with me way back when.

THE MOUNTAINEERS BOOKS is the nonprofit publishing arm of The Mountaineers, an organization founded in 1906 and dedicated to the exploration, preservation, and enjoyment of outdoor and wilderness areas.

1001 SW Klickitat Way, Suite 201, Seattle, WA 98134

Photographs and text ©2012 by Steven Kazlowski
First edition, 2012
All rights reserved
No part of this book may be reproduced in any form, or by any electronic, mechanical, or other means without permission in writing from the publisher.
Distributed in the United Kingdom by Cordee, www.cordee.co.uk
Manufactured in China

Developmental editor: Christine Clifton-Thornton
Book design and layout: Jane Jeszeck, Jigsaw / www.jigsawseattle.com

COVER: *Young female grizzly bear wakes up from a nap and stretches her leg, doing bear yoga before she starts another afternoon of fishing. Chugach Bay, Alaska*
PAGE 1: *A young black bear boar, Olympic National Park, Washington*
FRONTISPIECE: *A polar bear sow and cub during fall freeze-up, Arctic coast, Alaska*
PAGE 3: *A grizzly bear sow at sunrise, Katmai National Park, Alaska*
THIS PAGE: *A young blond grizzly bear, Katmai National Park, Alaska*

Library of Congress Cataloging-in-Publication Data on file

ISBN (hardcover): 978-1-59485-675-4
ISBN (ebook): 978-1-59485-676-1

INTRODUCTION

BEARS SYMBOLIZE THE WILD. There is something inherent in all of us that connects us to the wild, and observing bears allows us to truly see that sense of wild that we find so spellbinding. Something about the beautiful, strong, majestic bear tugs at a string deep inside of us, reminding us that we, too, were once creatures who lived free. Bears might even stir up a bit of envy on our part. We are often attracted to the way in which bears seem to inhabit the landscape—they know who they are, they know what they want to do, and there is very little confusion about it. Bears share many of the same drives for life we do: the desire for food, shelter, and happiness. In the following pages you'll find an intimate look into the lives of black bears, grizzly bears, and polar bears through my experiences while photographing them over the course of fifteen years.

BEAR SPECIES

Bears are mammals of the family Ursidae. They are classified as *caniforms* or *carnivorans*, with the *pinniped*— fin-footed mammals such as seals—being their closest living relatives. There are eight species of bears in the world: the Asiatic black bear, black bear, brown bear, panda bear, polar bear, sloth bear, spectacled bear, and sun bear. Three of these species are found in North America: black bears (*Ursus americanus*), brown (grizzly) bears (*Ursus arctos*), and polar bears (*Ursus maritimus*).

Black Bear

Black bears are found in all types of terrain, from the southern United States to northern Canada and Alaska, and from the Smoky Mountains to the Rockies, in geography as diverse as the high desert of Nevada to the glaciers of Alaska. Because there are more documented human attacks by black bears than by any other bear species, it's often thought that people have more problems with black bears than with other bears. This is undoubtedly the result of a single fact: There are more American black bears in the world than all other bears on Earth combined, with a total population of nearly one million.

The fur color of the black bear ranges from deep black to cinnamon to blue to the white fur of the spirit, or Kermode, bear. This makes black bears a diverse

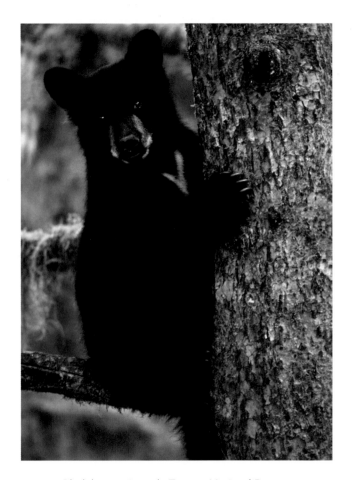

ABOVE *Black bear spring cub, Tongass National Forest, Southeast Alaska* OPPOSITE *Black bear, Kenai Fjords National Park, Southcentral Alaska*

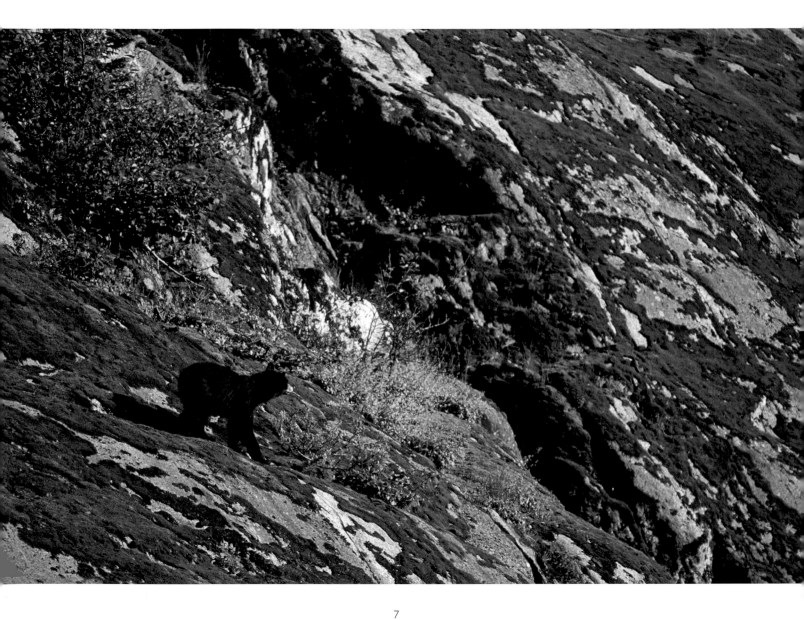

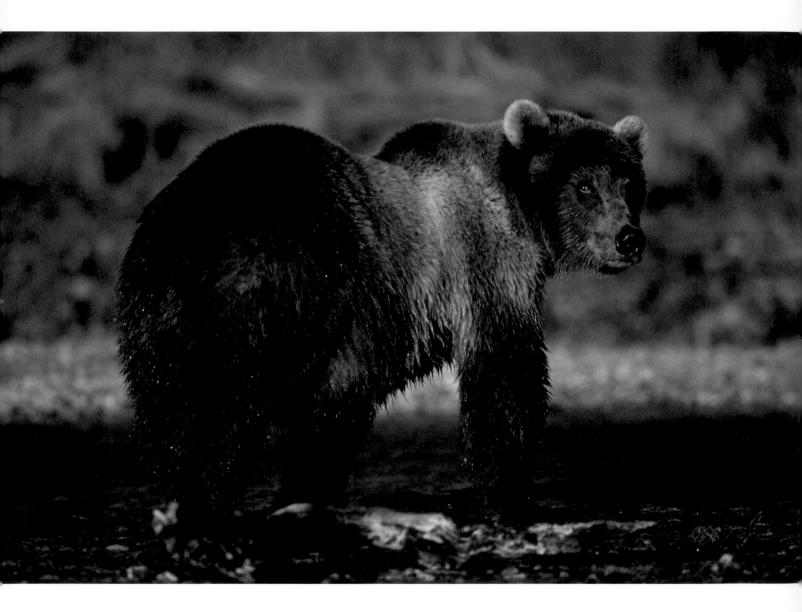

AVERAGE BEAR WEIGHT IN POUNDS

SPECIES	MALE	FEMALE
Black	250–400+	120–300
Grizzly	550–1,000+	220–450
Polar	800–1,600+	400–800

photographic subject. The black bear possesses an uncanny ability to adjust to—and disappear into—urban settings. Where I live now, on the Kitsap Peninsula in Washington State, black bears are present, but other than occasional tracks, I rarely spot them because of their ability to blend into the landscape. They have even been spotted within nearby Seattle's city limits, an urban center of more than 600,000 people!

The black bear is the ambassador bear of all bears. Because they are so widely distributed in North America, black bears offer the best chance for people to understand bears through observation. If you have an interest in seeing bears, you will most likely be able to find a location to view a black bear more easily than any other bear. Black bears are the ghosts of our forests, and their presence makes our woods richer. They have found their way, as the coyote has, to live in the footprint of man as well as in the wild.

OPPOSITE *Grizzly bear sow, Katmai National Park, Alaska*

Brown (Grizzly) Bear

Brown bears, also known as grizzly bears in some regions, can be found in areas of the northwestern United States, western Canada, and Alaska, as well as eastern and western Eurasia. They are the most widely distributed bear species in the world, with an estimated world population of about 200,000. They were once a powerhouse species in North America. At the time of Lewis and Clark's expedition across the American West, it is estimated that there were up to 100,000 grizzly bears in the contiguous United States alone. Today, fewer than 1,200 grizzlies survive in protected parks and wilderness areas within the Rocky Mountains of Wyoming, Idaho, and Montana, as well as in Washington's North Cascades. Due to expansion of human settlement, these animals have lost most of their former habitat and persist only in areas where their space and food needs are met, such as Alaska, where more than 70 percent of the North American population is found. Brown bears were listed as threatened under the federal Endangered Species Act in 1975.

A bear's size is often determined by availability of food, and Alaska's Katmai National Park is habitat to what are believed to be some of the world's largest grizzly bears due to the vast number of salmon that return to spawn in the region's rivers. Whether you call it a brown bear or a grizzly bear, one look at this animal

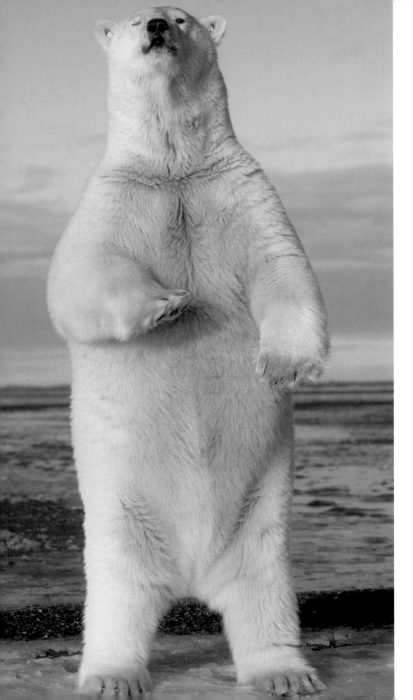

and the word "respect" comes to mind. Their massive size, power, and agility are always apparent.

Polar Bear

There are approximately 25,000 wild polar bears worldwide, with about 60 percent of those in Canada. Populations also inhabit Greenland, Siberia, Alaska, and Norway. Two populations occur in Alaska: the southern Beaufort Sea stock, shared with Canada; and the Bering/Chukchi Seas stock, shared with the Russian Federation.

Polar bears are one of the largest land predators in the world. They can reach more than four feet tall at the shoulder, and when they stand up on their hind legs they may be more than ten feet tall. Polar bears are the only bears that circumnavigate the globe as a single species. Their bodies are perfectly adapted to an environment of ice, water, and snow. This is shown by their ability to reach weights of more than 1,600 pounds in a land that would appear desolate and devoid of sustenance to most of us.

Compared with the two other bear species' North American habitat, the polar bear's expansive environment will possibly see the greatest changes in the shortest amount of time, due to the loss of sea ice brought about by climate change. These giant nomads

Polar bear boar, Arctic coast, Alaska

are one of the most charismatic animal species we have. I hope that the connection we feel to the polar bear will help us understand our own connection to the earth by making us become better stewards of our planet before they are gone.

BEAR EXPERIENCES

I've always had a deep love of nature. I love being out-side. There's something about listening to the birds and breathing in the fresh air that brings me peace. My love of the outdoors is a large part of why I became a photographer. I've photographed bears for fifteen years, and I still feel a sense of awe when I see a bear in the wild. It's an incredible experience: When you see bears in their natural habitat, you witness their power, and you know that they could harm you if they wanted to—but they usually don't. It's as exhila-rating as it is breathtaking. I can be easily frustrated in life; I get annoyed by stupid things, like trying to find a missing shoe or having to figure out the latest software upgrade. But being in the wild gives me a sense of peace and fulfillment, and all the distractions of daily life fade away.

Just like many people, I used to be afraid of bears. It took some time—and a few intense bear experiences—for me to understand that, when treated with proper caution and respect, bears are most often respectful in

REPRODUCTION

Bears mate in the spring and early summer, and the female gives birth in a maternity den during midwinter. Females go into a form of hibernation, fasting for up to eight months while in the den. Unlike other hibernating mammals, while the bear's heartbeat slows its body temperature does not decrease. Because of this, the bear's period in the den is not considered to be true hibernation.

Both black bear and brown bear cubs weigh less than a pound at birth; polar bear cubs weigh less than two pounds. Litter size ranges from one to six cubs but is typically two or three. After giv-ing birth, the mother will remain with her cubs in the den until the cubs are strong enough to exist outside the protection of the den, usually after two to three months, or, for a polar bear, when the cub weighs between 22 and 33 pounds.

Polar bear mothers will allow other females to watch over their yearling cubs, while black bear and grizzly mamas keep their cubs at their sides. Black bears generally stay with their mother for seventeen months. Grizzly and polar bear cubs usually stay with their mother for two and a half years, or even three and a half years.

TRIVIA

- Bears taste the air with their tongue. It's almost as if the wind can push a bear to the left or right, depending on what scent is carried by the wind.

- Bears are typically shy and often scare easily.

- They can eat up to 15 percent of their body weight in one day.

- The spirit bear, a subspecies of the black bear, is as rare as the giant panda.

- Bears gain up to 200 pounds between spring and fall.

- They can live 30 years or more.

- Bears can run up to 35 miles an hour for a short distance.

- Polar bears and grizzly bears can crossbreed—although they rarely do.

- The largest bear on record was a polar bear, at 12 feet tall and more than 2,200 pounds.

return. Once, a black bear female with a cub was not too happy with me when I tried to move past her on the edge of some boulders along a steep part of the creek. She put her ears back and head up, and started moving stiffly in my direction. At that point I decided that it would be wise to move as quickly as I could (without running) to get out of her personal space—a space that can be different with different bears in different situations. Once I increased that distance, she quickly turned and went back to what she was doing. She was speaking to me, and I chose to listen.

In another case, two young subadults came ambling down the creek. After I backed away to give them more room, they continued in my direction. I decided the best course of action was to hold my ground with these two curious youngsters. After they got close, they showed a slight sign of aggression by bluff charging me. I then showed them a larger sign of aggression by yelling at them and kicking my feet. At that, they turned in another direction. But if I had reacted in this fashion to the female bear in the first example, the encounter likely would have had a different ending.

It is important to understand each situation when

OPPOSITE *A collared grizzly bear sow and her three cubs travel the tundra of the central Arctic coast, North slope of the Brooks Range, Alaska*

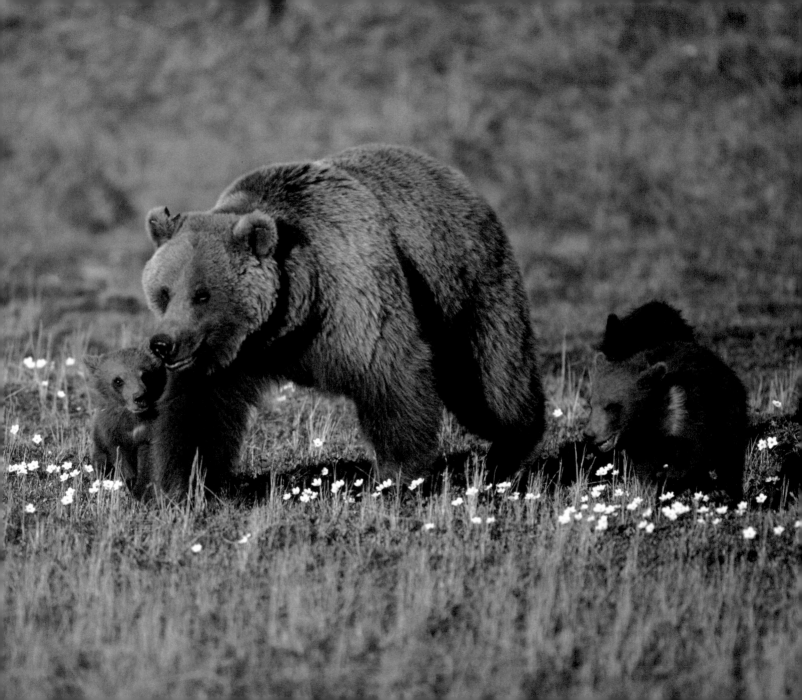

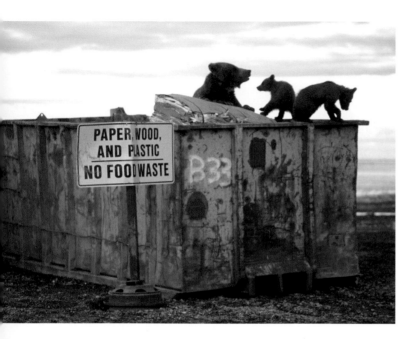

A collared grizzly bear sow and her young cubs dig through a garbage dumpster in search of food. Prudhoe Bay, Alaska

are present the same way we might assess them. I've seen a bear walk within feet of me, over and over again, once it decided that I wasn't a threat. Most bears aren't interested in eating people, the same way most people in traffic aren't interested in getting in an accident. Bears are interested in eating bear food, which doesn't include people except in the most extreme cases, such as with a starving animal. Black bears and grizzly bears are super herbivores. They'll take advantage of eating meat when they can in the form of salmon, elk and moose calves, and other small animals, but the majority of their diet is composed of berries, flowers, herbs, and other vegetation. You might hear of a rare, rogue bear that has attacked a human, but such occurrences are very rare. When observed properly, the bear's danger is more mythical than actual.

On a trip to the Katmai coast in Alaska, I observed that bears clearly communicate their preferences with an unspoken language: the angle of the ears, the rising hair, the snapping of the jaws—these are all signs that an animal is uncomfortable, and it's time to give the animal some space. Over time, I've learned to be more comfortable around bears by watching for such signs. There is a physical transition that occurs when your mind and body move from fear to acceptance to that next emotional place when you're in the wild. In a very

you are near a bear. I always have an exit plan to remove myself from the situation when I'm in bear territory. A bear might not be aggressive one day but might be the next, so one can never become complacent.

Having lived among the bears, I've learned that they aren't always aggressive; in fact, they are quite sensitive. They will assess a situation in which humans

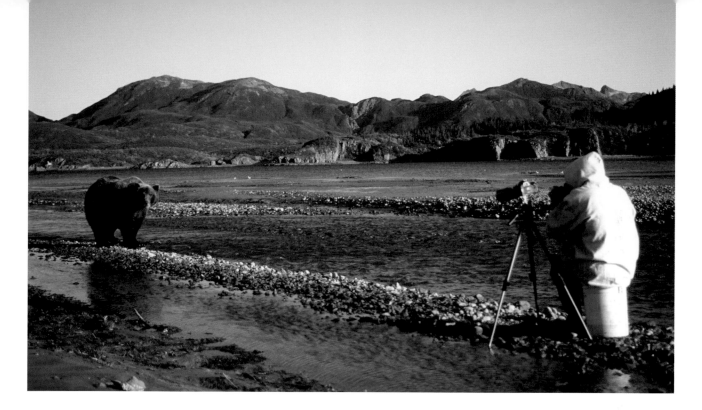

visceral way, there's a sense of relief that comes with the knowledge that you're most likely not going to be killed or used as a play toy.

For me, spending time around bears isn't about thrill seeking; it's simply the enjoyment of a moment that is so special I'll remember it for the rest of my life. It's the same sense I have when I'm rolling around with my baby boy. It will probably only occur during a limited span of time, and it gives me a feeling of pure joy. In both cases, it's the rare opportunity to experience a childlike sense of wonder as an adult.

A grizzly bear walks along a river looking for returning salmon as a filmmaker captures footage. Katmai National Park, Alaska

I've been asked why I continue to photograph bears. Haven't I taken enough bear photos? But it's not about the number. Every bear is as different as the experience of seeing one in its natural habitat, and not everyone is as lucky as I am to have the opportunity to witness it. Sharing those moments with others through photography makes them even more meaningful to me.

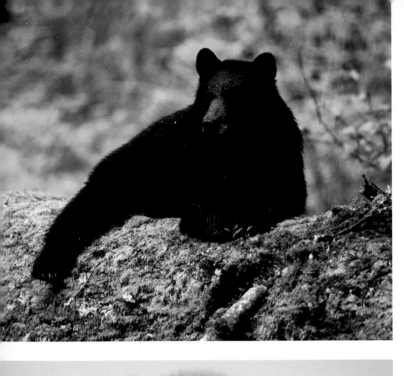
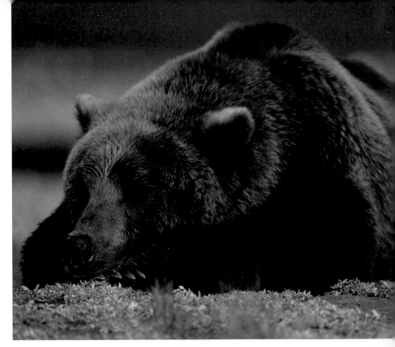
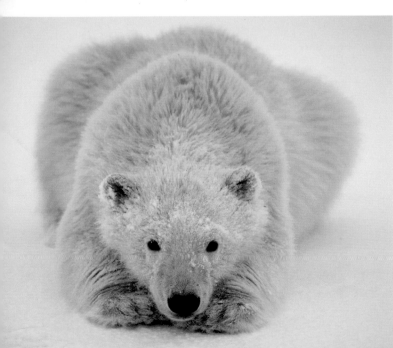
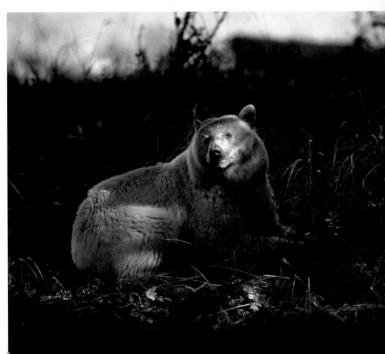

BEAR PHOTOGRAPHY

Bears are a great subject from which to transform a two-dimensional photograph into a three-dimensional view. You can't put sound or feeling into a two-dimensional image, but if you capture the right light and the right expression of a bear, it can seem to leap off the page, giving the viewer a sense of what it would be like to witness the subject in person. The larger meaning of what happens when someone connects to an image has to do with the combination of composition, light, and subject. A great image evokes the sense of an experience condensed, capturing all the elements and allowing the viewer to experience the image as if the experience it captured were their own.

Every time I see a bear, I'm captivated by the strength of the animal. The first time I saw a polar bear rise up out of the water and walk ashore was a very powerful moment. It's not just the bear itself; it's the bear in the wild, in its natural habitat. For me, the sense of the bear and the environment are wrapped up in one experience. Wildlife and outdoor photography is one of the more impactful ways we have to document and share the natural world, so that we can all have a better understanding of nature. If you are sensitive to

OPPOSITE (CLOCKWISE FROM UPPER LEFT) *Black bear; brown (grizzly) bear; black (spirit) bear; polar bear*

an animal's habitat and behavior, the animal may accept you without having to change its behavior. This allows us to observe and in turn share what we've observed, so that the natural world is better understood by all. If we know something is there but never see it, we will be less likely to think about it. Photos can give us a sense of place. Seeing the evidence of the natural world helps us make a connection to that world, which is our world, and speaks to our ability to understand ourselves and connect with the compassion in ourselves. It helps us to be more human.

BEARS AT RISK

Bears tend to be very adaptable. During the spring, when southern bears are digging roots to eat, northern bears, facing frozen ground, will hunt living prey instead. While black bears are the most adaptable of all the bears, even they need space to roam. Roaming is food-dependent: Male black bears can roam hundreds of miles to forage for food across large overlapping territories, while females share smaller overlapping territories. Bears adapt to their habitat, as well: If in northern and high elevation areas the winter freeze lasts longer than usual, bears will hunt rather than dig for roots to eat, since digging is not possible. It has been reported that grizzlies in Yellowstone National Park have found a new food source during summer months

in the higher elevations: Miller moths and their larvae (army cutworm). It is estimated that a Yellowstone grizzly now consumes up to 40,000 of these moths—or 20,000 calories' worth—per day. But adaption can go only so far.

These moths and many other species on which bears are dependent are potentially at risk due to climate change. The complex issue of climate change impacts animals and habitats in myriad long-lasting ways. With ocean acidification due to climate change, there could eventually be a loss in small organisms known as copepods, which first-year salmon almost entirely feed upon. As salmon runs are disturbed, many bear populations dwindle as a result. And the well-documented loss of sea ice due to climate change already is having an impact on the polar bear.

In addition to climate change, human development, in its simplest form, affects bears by reducing habitat, and loss of habitat means loss of bears. Most of the grizzly bear's original habitat in the contiguous United States has been lost to human and agricultural development. Nearly 60 percent of the world's coastal temperate rainforests have been logged or developed. The spirit bear's habitat represents one quarter of what remains. In this case, an animal like the spirit bear can help us focus on a problem and cause us to take action in the form of conservation to save a few remaining stretches of rainforest from commercial logging, holding a part of a fragmented ancient ecosystem intact.

What is the importance of saving ecosystems and the animals such as the bears that live within them? Humans are part of these ecosystems as well, and changing them changes us—not always for the better. We benefit at numerous levels from having cleaner air, cleaner watersheds, and diverse plant and animal species. Better land and resource management will result in a better quality of life for humans as well as animals, and allow us to understand our connection to the earth at a sustainable level. There is a finite amount of space in the world. Without careful thought about how we live, the bear might not be the only species that has no place to go.

OPPOSITE *A curious young bear investigates a remote camera 1002 Area, Arctic National Wildlife Refuge, Alaska*

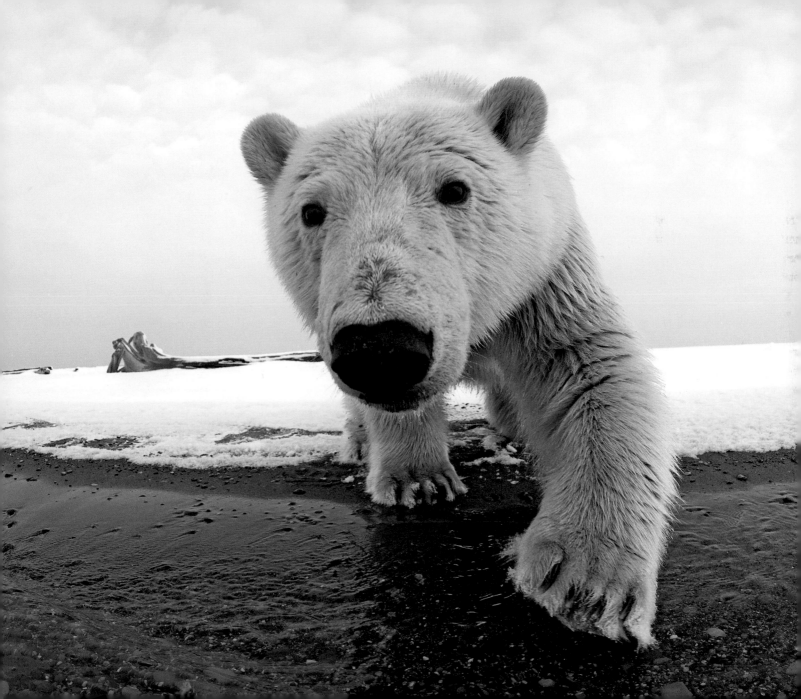

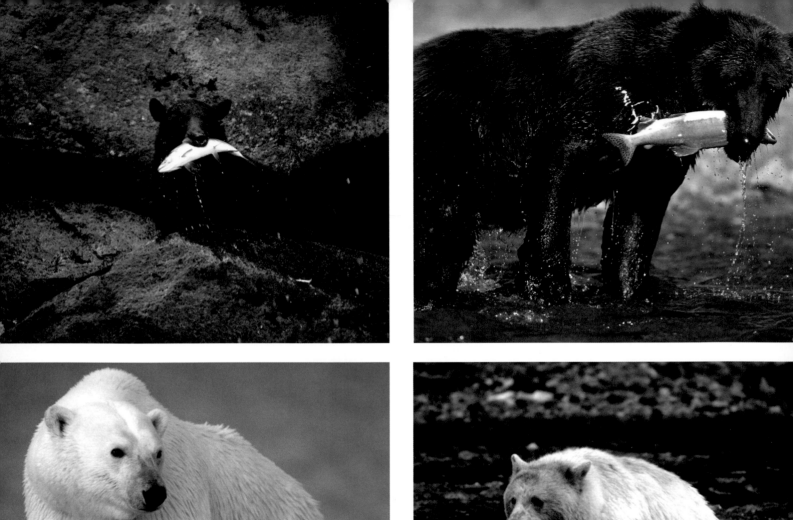

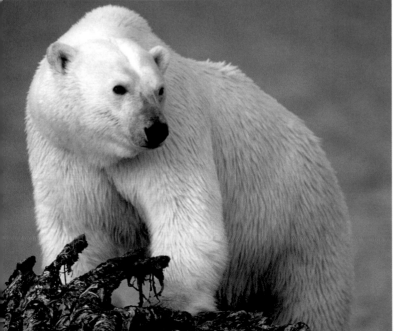

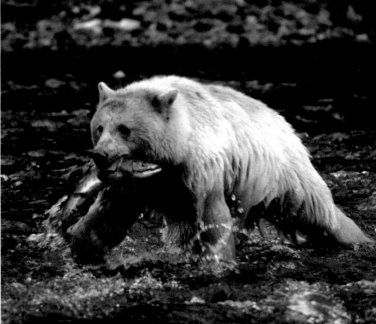

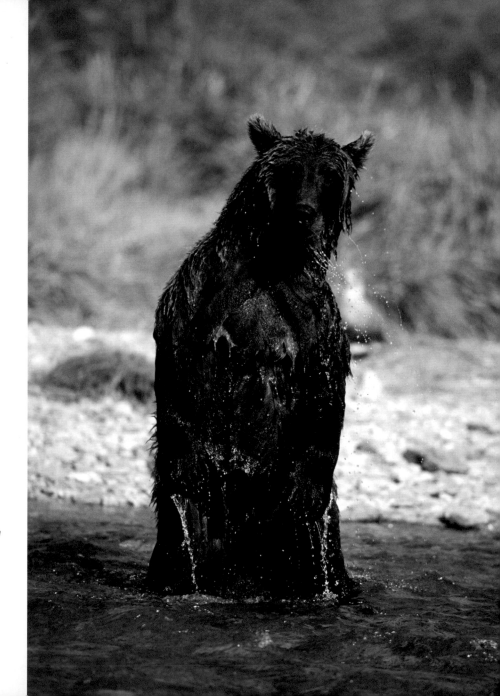

OPPOSITE (CLOCKWISE FROM UPPER LEFT)
A black bear with fish; a grizzly sow with pink salmon catch; a spirit bear sow with chum salmon catch; a male polar bear with bowhead whale carcass RIGHT *A massive grizzly bear boar looks for pink salmon moving upstream. Katmai National Park, Alaska*

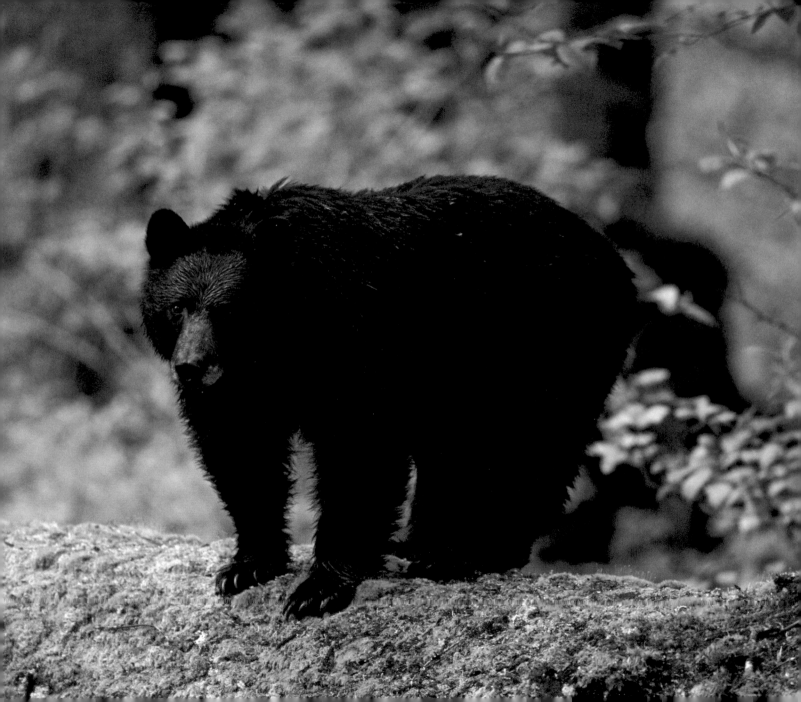

BLACK BEAR

Enchantment

Enchanted Valley, in Washington State's Olympic National Park, is just one among thousands of valleys in the Pacific Northwest where black bears can be observed in their natural habitat. Giant trees, raging rivers, and abundant wildlife make for an incredibly varied and prolific photography experience in this small valley.

A trail along the East Fork Quinault River leads into the land of Enchantment, also called the Valley of 1,000 Waterfalls. A place lost in time with no knowledge of the populous areas outside this mountain range, the valley in springtime teems with black bear, herds of Roosevelt elk and blacktailed deer, and countless other creatures. Its green meadows are nestled between mountain peaks more than 6,000 feet tall. The world's oldest Sitka spruce sits stately on a hillside just above the valley floor. During spring, temperatures can drop below freezing at night and, if it's

OPPOSITE *A stout young male black bear stands on a downed old-growth log. Olympic National Park, Washington*

sunny, rise to sixty or seventy degrees during the day. To get there, you must backpack fifteen miles in, carrying everything you need to stay warm, safe, and fed on your back. Up and down and up and down, again and again, over multiple rolling hills—and yet, in spite of all the climbing, the final destination is only fifteen hundred feet above sea level.

When I arrived at the top of the valley, I was exhausted. My bones ached from the climb, but the beauty of the valley helped me heal. The valley is lush and full of animals, all waiting for the snow to melt so they can head to the high country. Elk run through the ferns, and black bears feast on the rich vegetation as if they were cattle grazing in fields. Hummingbirds flit from flower to flower.

I dropped my gear at about a thousand feet and made camp under an old-growth tree at the valley's entrance, with the river fifteen feet away. The tree helped keep me dry as rain spilled forth each evening. One night, so much water entered the watershed that thousand-pound boulders were pitched down the

crashing river as if they were pebbles being thrown across a yard.

During the day, I walked the meadows. Anywhere from twelve to more than twenty-five black bears were feeding on the lush grasses. The bears paid little attention to me as they fed. As the days went by, my senses became heightened from the lack of civilization's noise, and I became more in tune with the richness of my surroundings. Here it was very clear to me that I am a wildlife photographer because being in nature, even with all its hardships, brings a kind of peace to me not found anywhere else.

In the Enchanted Valley, it can be difficult to get a good shot of a bear because there is so much dense growth obscuring the view of the bears. But this also allowed me to get a little closer than might be prudent in an open landscape. I found myself on a slope where bigleaf maple dotted the hillside, all crooked and cockeyed, covered in moss. Nearby, in a field on the hillside, were a mother and her cub. She spotted me and sent the cub up a tree, and then shot away—but not too far away. She, her cub, and I were triangulated as she posed for fifteen minutes on a downed old-growth tree. Then I backed away to encourage the cub to rejoin its mother. It was sufficient. That's the beauty of this place; I know that around the next tree might be another opportunity to photograph a bear.

For days I photographed young bears that were somewhat unconcerned about my presence. Then one afternoon, a big boar entered the valley with an overwhelming sense of brute force. He weighed at least 400 pounds and walked with stiff legs to make his presence known. All the other bears scurried away, as if he were a reigning king. He ignored me until I moved closer to take a photo—then he turned and gave me a look with the full force of his intensity. I quickly grabbed a few photos, wondering if it was a good idea, before I scurried away just as the other bears had done. Watching this large boar, compared to a young bear, one can understand why bears need to be respected.

Every day I worked my way farther into the valley, finding where the bears were grazing, and photographed them. The trees were immense. Bigleaf maples were covered in moss, and bears slept in the crux of trees as if they were giant mossy hammocks. It was springtime: There was pollen in the air, I could smell the fragrance of the blooming trees, and the oxygen was moist and clean, so each breath I took was fresh and damp. Each morning, the fog lifted from the valley floor to reveal the magic of the teeming landscape, and each day I

OPPOSITE *Very young black bears can chew, tear, rip, dig, and climb as well as adult black bears that are many times their size.*

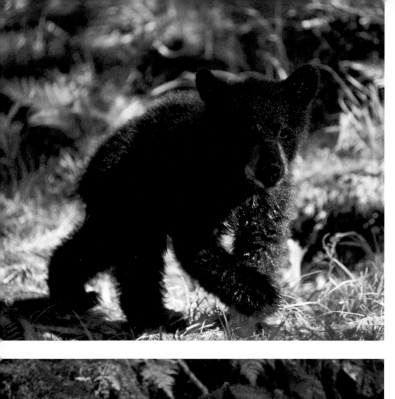
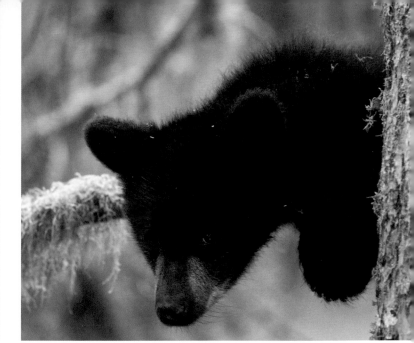
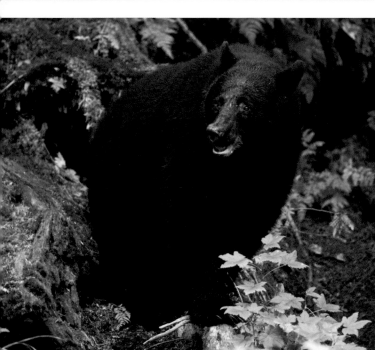
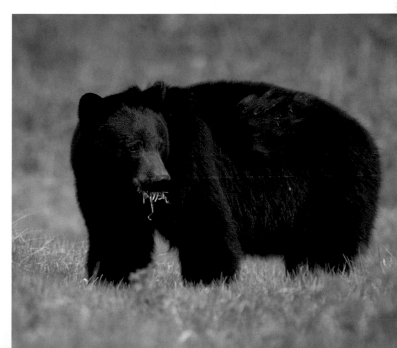

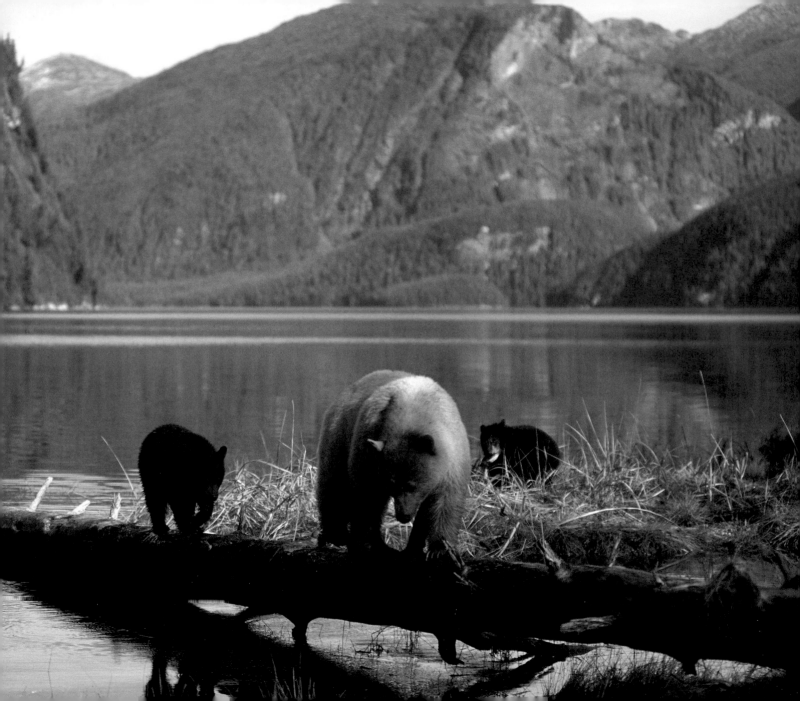

floated away into the beauty of it. It became a trip less about getting a photograph and more about the experience of living in the enchanted land of the black bear.

Spirit Bear

Some Native Americans believe that when the glaciers of the ice age retreated in the north, the Creator left some bears white to remind man that ice gave life to the land. These white-colored black bears are known as Kermode bears, and more commonly called spirit bears. They are extremely rare, lacking a gene that gives the coat of the black bear its dark color. Despite its white coloration, the spirit bear is not an albino. Its skin is black underneath the white fur, and its nose is black to pinkish brown. Biologists estimate that there are fewer than four hundred spirit bears left in their central habitat, on the west coast of British Columbia, Canada.

The rainforest here in western British Columbia is an amazing place where land is soaked by water. The region receives hundreds of inches of rain per year. Draped in lush vegetation and fog, with rivers running out of the mountains, it is habitat to bears, wolves, giant raptors, frogs, salamanders, and many other creatures. The vegetation grows rapidly because of the intense

OPPOSITE *A spirit bear sow fishes with her black cubs. Central British Columbia coast, Canada*

moisture, and the landscape appears to be in constant motion. Douglas-fir and cedar trees that are thousands of years old tower above saplings. The diversity of flora and fauna found in an old-growth forest such as this makes for an extremely rich environment. I can look at the same view a thousand times and always see something different. It's an endless education that never becomes stale.

A friend and I set out together to the Kitasoo Spirit Bear Conservancy area, which hosts more than fifty salmon streams and is habitat to all the dominant regional rainforest species—plus a small population of spirit bears. The tips of the mountains are covered in snow and ice that once reached down to the bay year-round, and water continually pours off the mountains. We arrived at a small bay and set up camp near a stream where there were indicators that bears had been feeding.

We awoke the next morning to a downpour. After a day of constant heavy rain, the entire side of the mountain became a river, with water bubbling up through the ground, turning our campsite into a pool of water. It was a challenge to keep our camera gear dry, and the rain made photography almost impossible. We routinely hiked up the river where the salmon were spawning, but after a week and a half of waiting in heavy continuous rainstorms, we'd seen only a single grizzly bear. We packed up our gear and headed toward Boulen Bay.

The curve of bowl-shaped Boulen Bay is marked by an ancient forest untouched by modern man. Crabapple trees cultivated by native people hundreds of years ago dot the base of a stream. At low tide, giant rocks and mud flats make it possible to navigate the rim of the bay.

The rain continued as we set up camp and our new location didn't change our luck. After eight more days with no white bear sightings, we moved camp away from the main stream to a small overflow stream. We picked a spot a few hundred yards away to make a blind from which to wait and watch for bears.

On the ninth day, a grizzly bear appeared. It was a mixed blessing from a photographic perspective. After what seemed like endless rain and waiting, we were happy to see a bear, but also a little disappointed, because the odds of a spirit bear feeding next to a grizzly seemed slim.

That evening, we sat on rocks outside in the damp rain while we heated up our freeze-dried supper. It seemed likely that we would not see a spirit bear on this trip. We were feeling the rain and the long days and the disappointment, and there was little talking as we ate.

Then, at the curve of the beach, a sow and two cubs ambled down to the high-tide mark, heading right toward us. The mother bear was not brown or black; it was …white. The creek, five feet away, was overflowing with water from the rain and jumping with salmon heading upstream to spawn. The spirit bear was coming to the stream—our stream—to fish. It took our breath away.

We quietly put our leftovers into bear barrels as we watched the bears meander the bank. By then it was too dark to take photos, so eventually we decided to go to bed, hoping that they would stay in the area. As we readied camp, the sow and cubs began moving up the other side of the stream to catch fish.

Once inside my tent, I realized it was completely soaked through. I emerged from the tent and turned to grab my Coleman stove, and heard rustling. The young sow had apparently settled down to sleep with her cubs next to a log some thirty feet behind my tent.

Startled, she charged at me, her hair up, ears back, jaws snapping. I grabbed some rocks as I backed up nice and steady past my friend's tent. She was ten feet away. I stood there with the rocks in my hands, certain I was about to get pummeled by a bear, fear and aggression within me. I spoke to her calmly. After a few tense moments, she eventually left with the cubs.

It was another disappointment. I was sure I'd scared them off and lost my only opportunity to photograph a spirit bear. In spite of this, we decided to stay, and the next morning we hiked to the blind and patiently waited out of sight.

Early in the morning, the sow and cubs returned. We were elated once again. She continued to return each day to fish in the stream. Over time, she felt more comfortable with me and my camera. She began to show herself more in the morning and afternoon, and we spent the next six days photographing the spirit bear on the edge of the ancient forest.

Spirit bears eat mostly fish and berries, but they supplement their staple diet with deer and moose fawns, carrion, insects, plants, other fruits, mushrooms, and nuts.

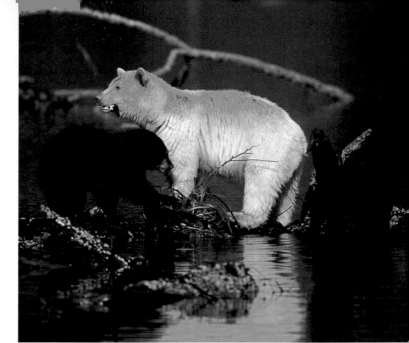

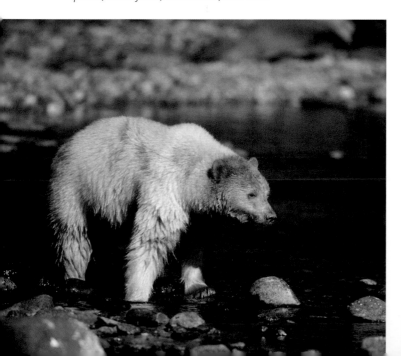

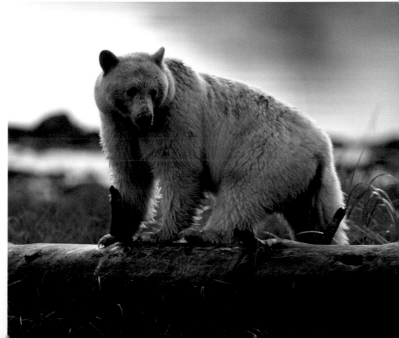

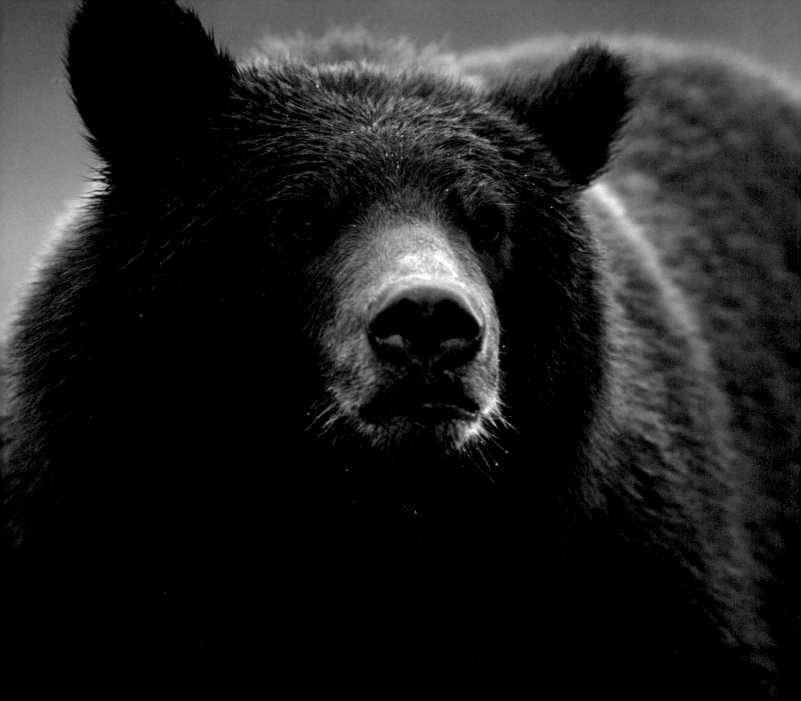

GRIZZLY BEAR

~

Wrestling

I was told about the existence of a blond grizzly bear during an autumn boat excursion south of Katmai National Park. I had to see for myself if it were true, so my travel companions and I decided to head north to see if we could track it down. We sailed up the rocky coast, past sea lions barking on rocky shoals, and entered Khugach Bay on a sunny early afternoon. On the far northern side of the bay was a large, grassy salt marsh several miles long, edged at low tide by equally large mud flats and framed by cottonwood trees, with a scenic mountain in the distance. The light was just hitting the sweet spot for afternoon fall photography in Alaska. As we turned off the motor and got ready to go ashore, we noticed a few bears spread out across the mud flats and salt grasses as the tide was retreating. Then, unexpectedly, we saw it: a young, white bear walking down the flats—the blond grizzly we were looking for.

As we watched, the blond grizzly and another young, dark grizzly walked up to one another, shaking

OPPOSITE *A young grizzly bear, Katmai National Park, Alaska*

their heads together—signaling an interest in playing. They were four or five years old, like teenagers in human terms, but they stood eight feet tall as they rose on their hind legs and took a firm grip on each other before wrestling to the ground. The game was friendly, but as with all bear wrestling, could turn into a fight if things got out of hand. They roamed the mud flats while they batted, parried, and tackled. They came within fifty feet of us but we continually backed out of their way, not wanting to interrupt their play. They fought for hours as the sun descended in the sky and the tide dropped away from the land. Finally, with the sun on the horizon, the bears ended their play and then turned their attention to fishing as the sun disappeared.

The story of the blond grizzly bear seemed like a fable when I first heard it, unlikely to result in any real photographs. The chance we took resulted in an incredible opportunity to capture the energy of the sun, of the bears, and of this spectacular setting in one moment in time—except that this particular moment lasted for two and a half hours. It's the type of experience that drives a

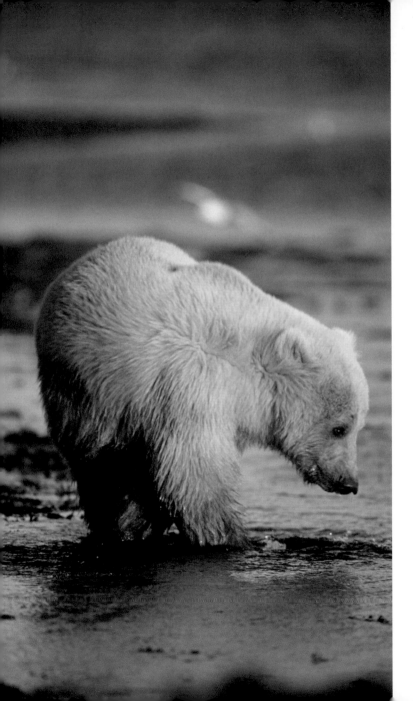

photographer to surmount all kinds of hurdles. Waiting and disappointment are part of the experience of being a wildlife and nature photographer. In photography, it's infrequent that everything comes together so perfectly that it's possible to capture such a magnificent experience in an image. More often the boat doesn't quite make it there, or the bears are on the wrong side of the light, or the clouds come in—but once in a while, everything comes together to make something magical that you might be lucky enough to capture.

LEFT *A rare blond grizzly bear searches for salmon. Katmai National Park, Alaska* OPPOSITE *Two young grizzly bears, a dark brown and a blonde, play for hours along the coast. Katmai National Park, Alaska*

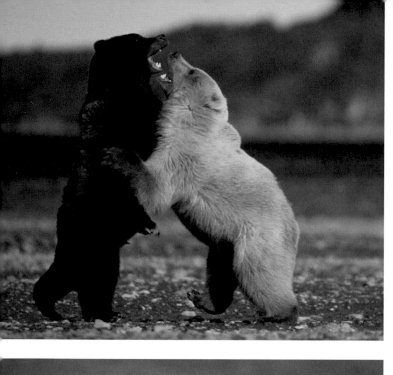
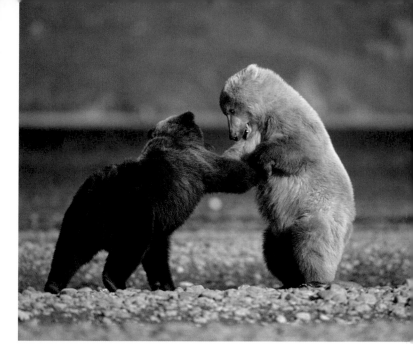
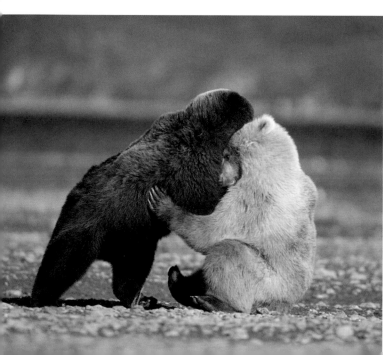
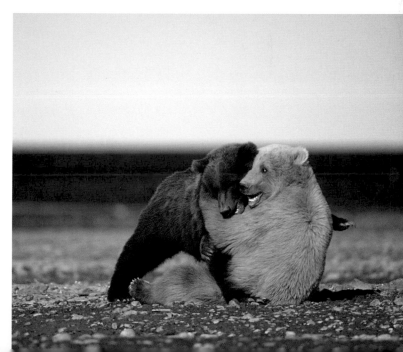

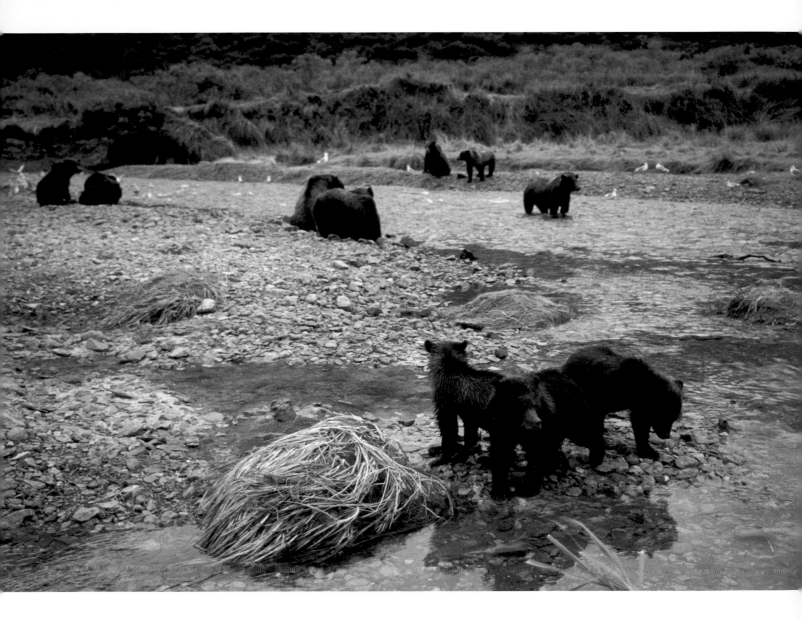

Fishing

Shelikof Bay, in Katmai National Park, was rumored to have a decent number of bears, but when I arrived one autumn morning and found sixty bears, I was quite impressed. The plan was for my friend and me to spend three weeks living among the bears while photographing them. Shelikof Bay has the third-highest tides in the world—tides of more than twenty feet. At low tide, the bears spread out up and down the river to fish, but at high tide, we found, they withdraw above the tide line to the brush—the only place where we could reasonably set up camp. When the tide came in, the bears moved to the brush to nap until the return of low tide, no matter the time of day or night.

All that separated us from the bears was a hip-high electric fence made of three strands—which, unfortunately, didn't work very well. It's a common practice to use portable electric fences in bear country; it's a sensible cohabitation practice with bears—not that they can't plough right through it. Throughout the three weeks, my friend couldn't sleep well, and I thanked him for staying awake, making it safer for me to sleep.

During the night, on schedule with the tides, branches crackled as bears moved through camp. I

OPPOSITE *Grizzly bear sows with their cubs gather at a bend in a river at low tide to fish for pink salmon.*

couldn't help but wonder if they were going to stumble into the tent. Cubs growled and grumbled as they passed by just feet away from the tent, following their mothers. This always left me feeling uneasy. Morning approached. In the dark, with the bears close by, I rolled over a few more times, listening to the sounds outside.

We finally got up in the dark with a goal of being down on the bank before the first light hit the top of the mountains. I checked for nearby bears before starting the fire and putting water on to boil, but all was clear. We had put the food in food pouches to keep preparation down to a minimum and also to be as clean and neat as possible. Breakfast was oatmeal and powdered eggs with a couple cups of coffee. When we were done, all food and garbage went into steel bear barrels to keep the scent down. I put on rubber boots for hiking around in water and a few layers because it would grow warm. On a nice, crisp autumn morning it can get up to sixty degrees later in the day.

I slowly made my way from our camp down the bank to the gravel mud flat as the fog lifted and the sun rose higher. There was a short window for photographing the scene, before the sun got too high and the light became too harsh. This can happen very quickly. When out in the wilderness, there is very little time to catch that mood, that sense of the morning, and then it's gone—and you must wait for the next morning to

try again. As the bears moved up and down the stream, taking up their positions to catch fish, I took up my position as well, to take photos.

The bay was still partly hidden in fog, but the smell of low tide told us it was there: the scent of live and dead salmon and salt hung in the air. Seagulls were squawking, and bears and fish splashed in the water. Streams trickled downhill through the gravel out to sea.

The young cubs were growling, hungry as they waited for their mamas to catch fish for breakfast at low tide. Older cubs pulled fish away from their mothers, who are typically less willing to give them food, reserving it for the younger cubs who trail after their

mothers. Some bears leapt at salmon while others waited in one spot and pinned the fish down as they swam by. Younger subadults looked around anxiously, unsure of what they should be doing. Big boars gently walked out of the creek with fish in their mouths, looking for a place to eat. The sound of eggs squirting from fish and fish being skinned meant there was a lot of fish; the bears were eating only the fattiest parts of the salmon and leaving the rest behind.

The Katmai coast is a magical place where you can see unexpected things, such as a boar in its prime taking a bath to cool off and clean up, appearing to groom itself just as a young man in his prime might do, and bears stretching in yogalike poses as they awaken in the morning. I've been to streams in areas where bears are hunted, and there I was unable to witness the bears during the day; the bears forage only at night, to stay out of the scopes of hunters. But this is the Katmai coast, where the brown bear lives free, unthreatened by humans—where they can be observed in daylight conditions, fattening up for the long winter sleep ahead.

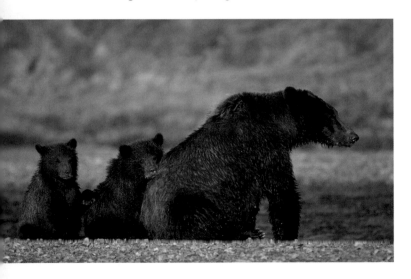

LEFT *A tired sow and her cubs wait patiently for passing salmon.*
OPPOSITE *The grizzly bears of Katmai gather in inlets, rivers, and streams along the coast to hunt for salmon, moving from one area to another as fish populations soar and then dwindle with the passing seasons.*

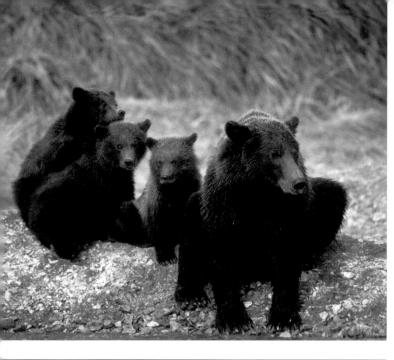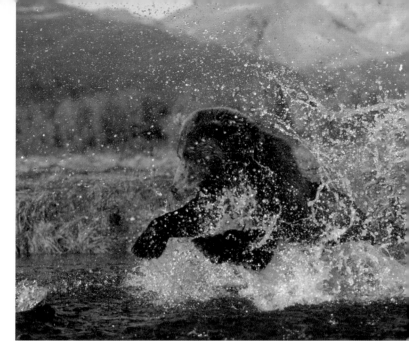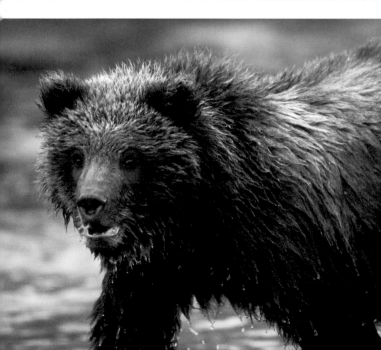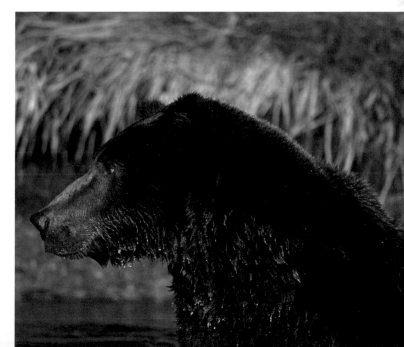

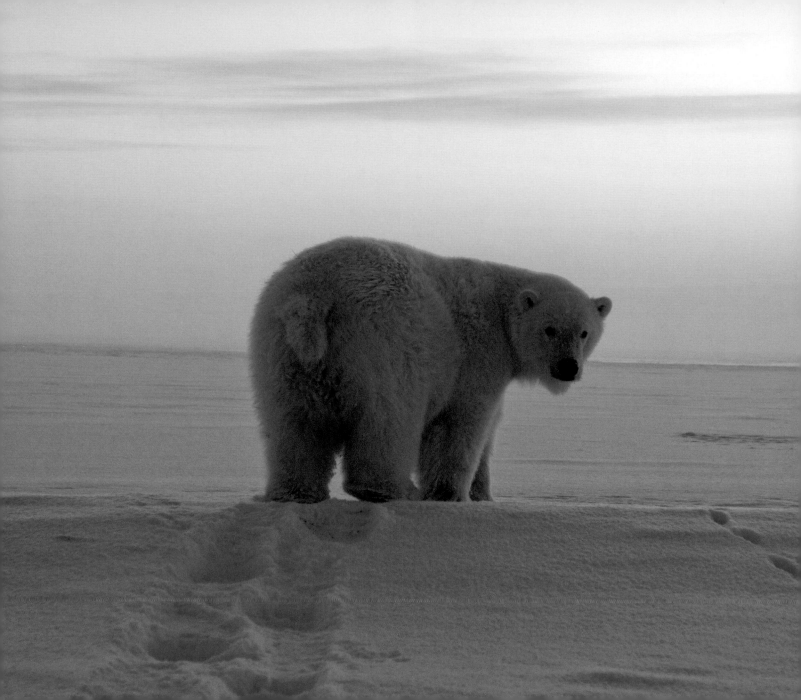

POLAR BEAR

Community

On the eastern Arctic coast in Alaska, autumn changes to winter as fast as you can exhale your breath. It's a dangerous environment where both humans and animals often live on the edge of existence. In a place where 1,500-pound animals walk onto land from the ice, and where people head outside at forty below zero, anything can happen. Viewing the polar bear in its Arctic habitat is one of life's most awesome and memorable experiences. The polar bear moves through the harsh environment almost effortlessly, while showing its true nature: powerful, agile, playful, social, and even tender.

After the subsistence bowhead whale hunt in early fall, the local Inupiats leave the whale remains on the beach on the outskirts of the village, and the polar bears do them the favor of cleaning up after them. The community has accepted the presence of the bears, and that acceptance has allowed me to witness the relationship between a great people and a great animal of the

OPPOSITE *Polar bear, Arctic Alaska*

Alaskan Arctic. This symbiotic relationship has developed over many years. With the effects of climate change, some of these outposts of sustenance have become a saving grace for polar bears, which wait longer and longer each year for the ice on which they depend to form. The bears now sometimes have to swim for hundreds of miles to reach the pack ice. The whale hunt remains allow the bears to add much-needed fat before heading back out onto the ice for the long winter.

When the ice starts to form on the lagoon off the coast, there is a small window of only a few hours a day before the ice becomes too difficult to navigate with a skiff. Most operators wouldn't take a boat out at this late date, but my guides Jack Kayotuk and Bruce Inglangasak are always up for a challenge. More than just guides, they are also my teachers, mentors, and friends. Jack's boat seemed to have a hole in it from banging around in the ice, but the light was perfect as the polar bears played on and off the ice. I asked Jack if he was up for a boat ride, and he and his wife, Alice, and I headed out.

I bailed continuously until we reached the far side of the lagoon, where we were stopped by the forming ice. I was completely focused on the photography, and after a while, Alice said, "It's time to go." The bears weren't that close; it didn't seem that dangerous to me. And everything was coalescing: the light, the bears, the ice. I didn't understand why she thought we should leave, until she said, "Turn around, Steve." And I turned around. The back end of the boat was almost filled with water.

Jack said, "We've got a few minutes." Knowing him, that meant we should have left a long time ago. Jack began to bail out the boat, but as quickly as he dumped the water out, it poured back in. It was such a spectacular day that I grabbed a few last images, photos that I don't often get the opportunity to take, and then we started the engine and pulled the boat away from the ice. I stood and bailed the entire way back to shore. This was a typical trip with Jack on the lagoon.

As the ice formed on the lagoon, the bears stayed longer at the whale bone pile, sleeping nearby rather than heading back to the ice. Early in the morning, I inched my vehicle out to the beach at two to four miles an hour. It's at this time of year that light drops like a stone. The Alaskan Arctic coast loses eleven minutes of light a day, eventually up to fifteen minutes. Thirty to forty bears can come out during an average day depending on the year, a dozen or so at a time, in family groups of mothers and cubs. I had been here for weeks already, and they were accustomed to my presence. I turned the vehicle off and sat and watched. Eventually I began to cautiously photograph the bears. They are truly among the great hunters of the north. And at times like this—waiting for the pack ice to form—they are also surprisingly social. They remind me of the Inupiats of old who traveled apart to hunt and then came together in groups to share the hunt and socialize. The polar bears live that same lifestyle.

The temperature ranged from zero degrees to twenty degrees. In Alaska there's a saying: There's no such thing as bad weather, only bad clothing. I wore layers that I could shed as needed. I didn't bring a thermos of coffee; I usually woke an hour or two before sunrise, and sat drinking coffee, thinking of the opportunity I might have that day, and enjoying that time very peacefully and quietly. I might bring a snack, but the excitement of the day is typically stimulating enough.

It was around five degrees when the pink of the sunrise slid above the ice fog and below the clouds. Before the winter's night fell, during the short period of daylight between the rising and the setting of the sun, the sky was continually pink. The bears were black silhouettes against the fog.

RIGHT *A group of polar bears congregates at whale remains along the Arctic coast in autumn.*
BELOW *A sow and her two-year-old cubs scavenge for food at a bowhead whale carcass.*

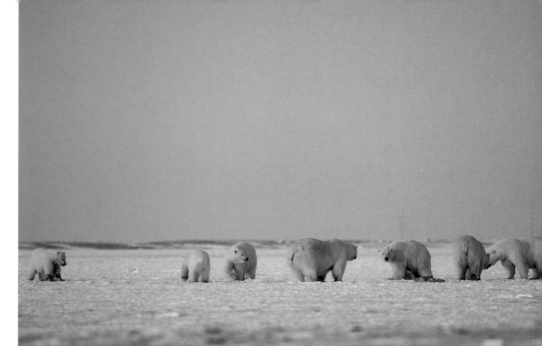

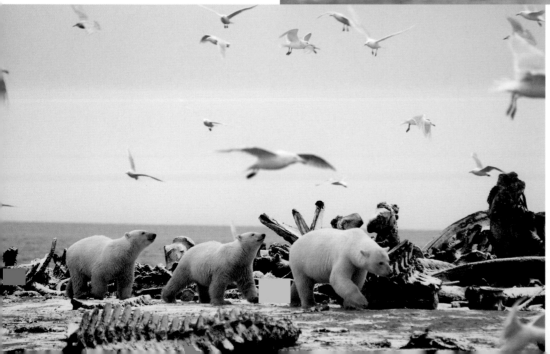

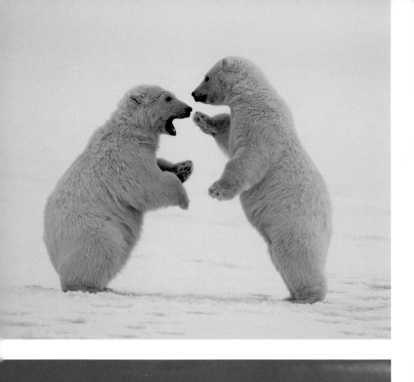
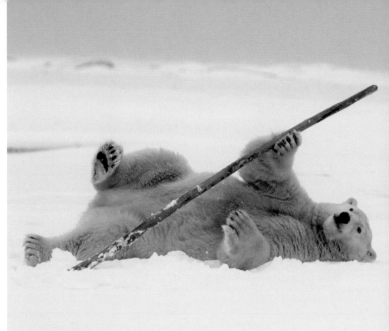
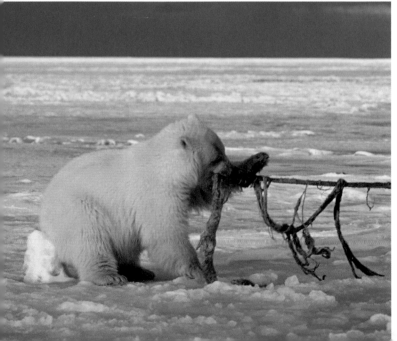
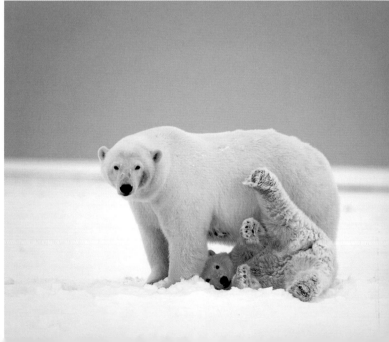

In wildlife photography, light is the connector of the image. In the Arctic, the composition of snow, ice, and water makes for an interesting background to tell the story of how this animal lives in its environment, with the light tying it all together.

Play

Psychologists tell us that, by nature, humans are born to play. It's instinctive, relaxing, and stimulating. Play connects us to other human beings, is fundamental to our growth, and is a factor in our survival. This assessment may very well apply to other species as well.

In the autumn, polar bears congregate to feed as a community, and you can easily see the relationships between the bears. Sisters and mothers and cousins visit with each other. Just like women who meet in a park with their children for a playdate, the mother polar bears will watch from a distance as two or three sets of cubs from different litters play together and box and snuffle in the snow. It's almost as if it's a nursery for the clan. I never get bored of this playfulness, of watching cubs play tricks. They sometimes pretend to be asleep while slowly pushing themselves toward me

OPPOSITE (CLOCKWISE FROM UPPER LEFT) *Spring cubs play on newly formed ice; a sow plays with a stick; a sow protects her playful spring cub; a cub pulls blubber from a whale carcass.*

with one leg to get closer, and they often try to engage me in their games. This interaction between animal and human shows that polar bears love to play, and, in my experience, they do so more than other bears. They seem to enjoy life as they play in social groups with each other. It turns work and education for the cubs into pleasure. What better way to learn how to hunt or fight than through play?

The beauty of polar bears, as is often the case with wild creatures, is displayed best by depicting their innocence and youth. When photographing young cubs I am able to capture this spirit. I sense the same energy and curiosity when I watch my young son, for whom everything is wonderment, everything is new. One springtime evening on our farm, an owl silently flew into the dusky night sky fifteen feet above my son's upturned face. He went from surprise to awe as the owl spread its wings and swept by. I could see that it was something he'd never expected. In both a young child and a young polar bear cub, you can see an expression of the same amazement at witnessing the world for the first time. My son's eyes opened wide, his mouth dropped open, and he made a soft cooing sound. His look showed that what he saw of that owl had made an impression on him.

Polar bear cubs are curious and playful. Their personalities are right on the surface. If they're a

grumpy little cub, they're a grumpy little cub; if they're a happy little cub, they're a happy little cub. A grumpy cub whines at its mother, refuses to do what she wants it to do, growls more, and starts tussles with other cubs. A happy cub shows more behavior expressing curiosity, plays more, and is less obstinate with its mother. Does that sound familiar to you?

One autumn, I photographed a mother polar bear that had broken her leg, and the next year she returned with two of the feistiest one-year-old cubs I had ever seen. They made it their daily routine to come over to my vehicle and say hello, sometimes lying down nearby and falling asleep. This allowed me to get an intimate look at the lives of these cubs, observing their intelligence, happiness, playfulness, love of life, and personalities. The ability of this sow with a broken leg to raise two cubs spoke to the bear's resilience and strength—an incredibly strong mother who defied all odds to not only survive, but to thrive with her offspring. She returned the following fall with her now two-year-olds in tow, and I was happy to see the family again.

I, too, learn from watching polar bear mothers: I've spent thousands of hours observing as they kept close eye on their cubs with what appeared to be an empty stare—an example of a parent exercising extreme patience. On walks with my young son, he might be drawn to a puddle and begin splashing for five minutes, then ten minutes, then twenty As I begin to feel impatient, I think of the great patience of the mother polar bear, which helps me to smile inside and let the boy play in the puddles until he's content.

Until they're mature enough to know how to hunt for their own food, polar bear cubs spend much of their time playing. When the work of survival begins, much of the play of youth is lost. Maybe we have the wrong approach to youthful education. Maybe a child who plays and is happy will learn the skills needed to survive. A youthful creature, whether it's an animal or a child, is unable to hide its true nature: It expresses itself fully without guile, without posturing. Sometimes we humans appear to lose the joy for life that polar bears seem to express so easily. There is much to be learned from watching polar bears as they live fully within their Arctic environment, in the moment.

OPPOSITE *A polar bear sow and her spring cubs rest along the Arctic coast.*

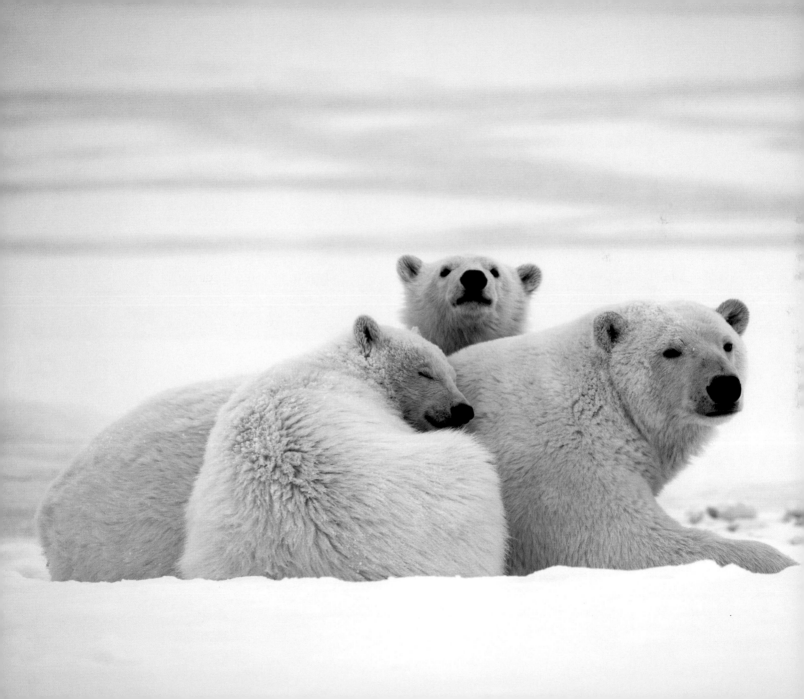

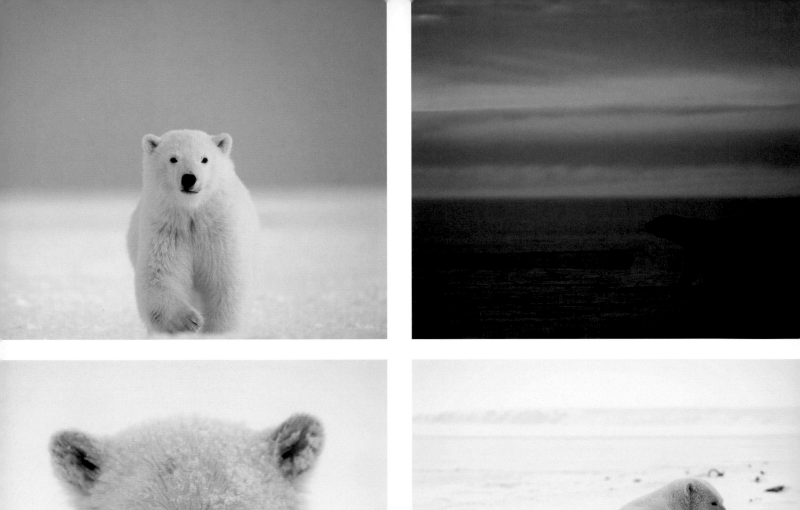
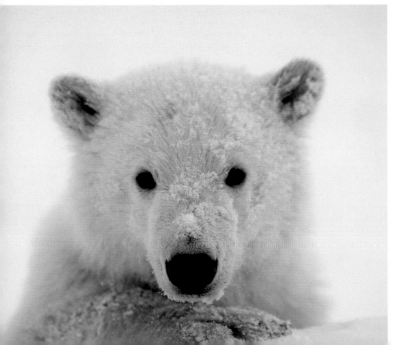
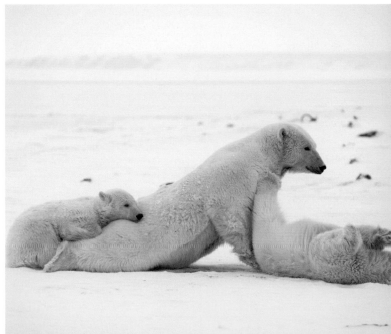

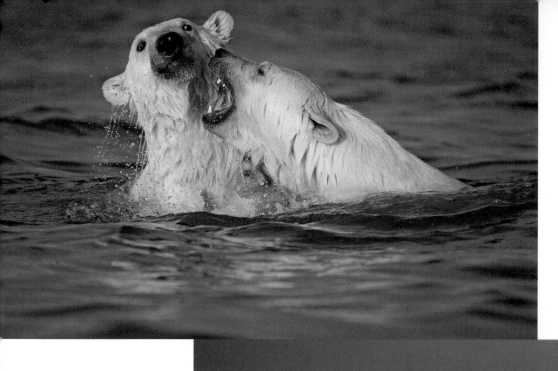

LEFT *Cubs play in the water.*
BELOW *A cub leaps into the water from a platform of newly formed pack ice.*

OPPOSITE (CLOCKWISE FROM UPPER LEFT)
A curious spring cub approaches from the pack ice; a bear travels in search of food at sunrise; a sow stretches as she rises with her spring cubs; a spring cub poses in autumn.

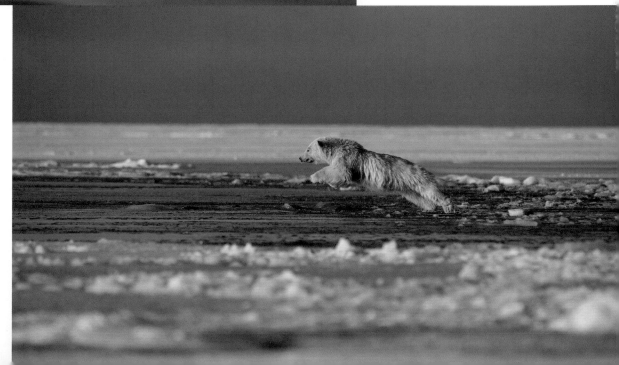

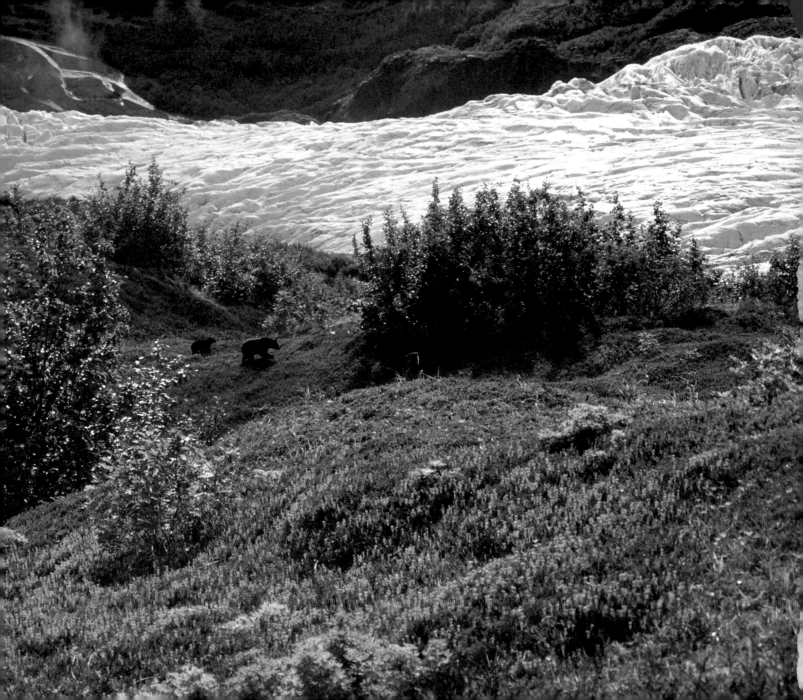

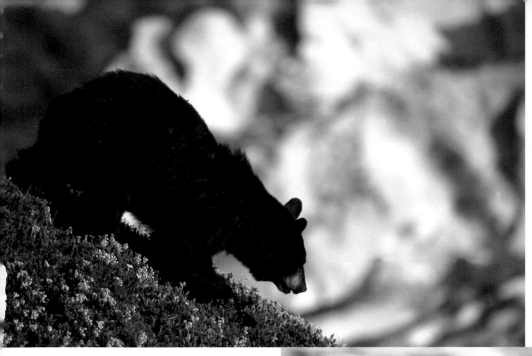

LEFT *Adult black bear, Exit Glacier, Alaska* BELOW *A sow with spring cubs, Exit Glacier, Alaska*

OPPOSITE *A black bear sow and her cub roam near a glacier. Kenai Fjords National Park, Alaska*

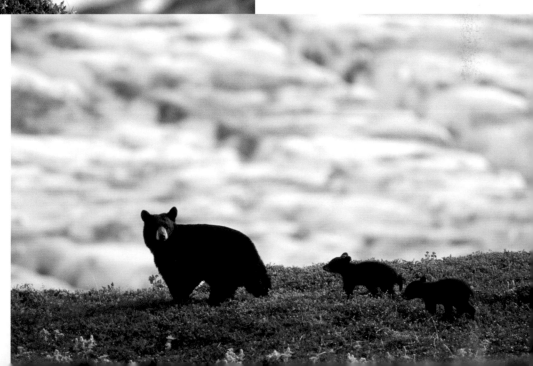

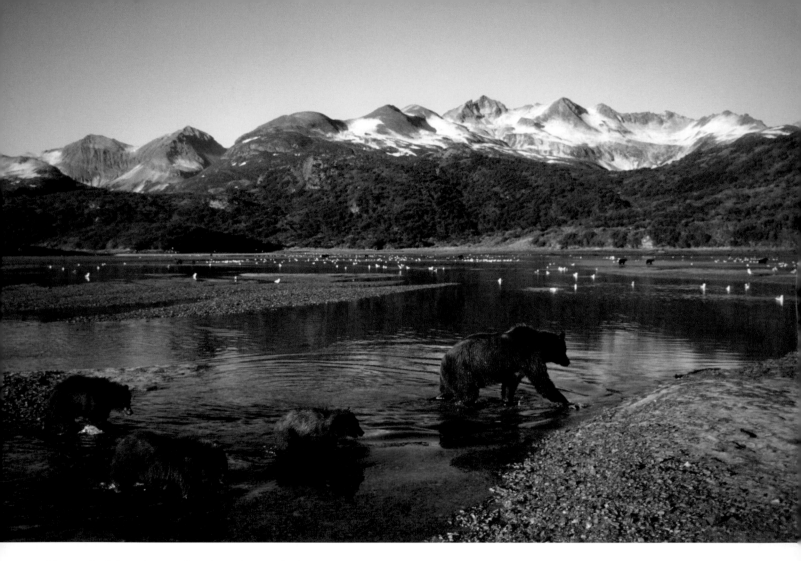

Three cubs follow their mother through a riverbed in search of pink salmon. Katmai National Park, Alaska

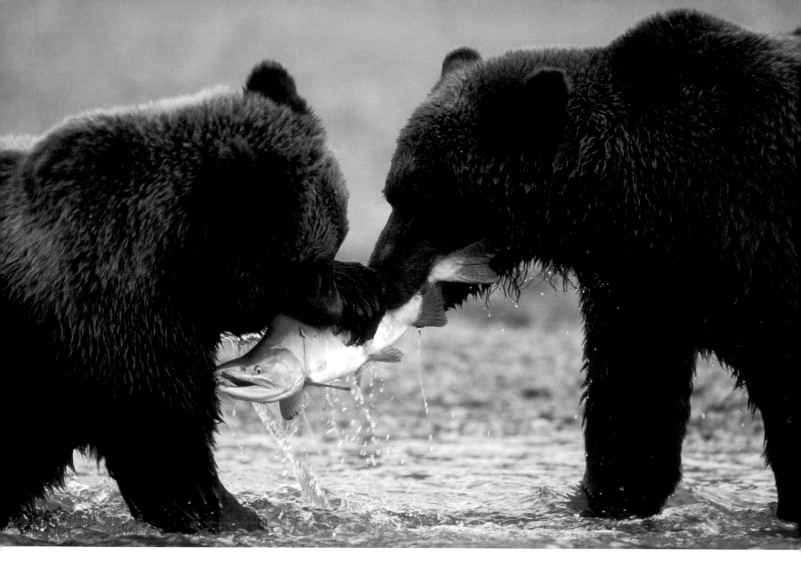

A cub attempts to take a pink salmon catch from its mother.
Katmai National Park, Alaska

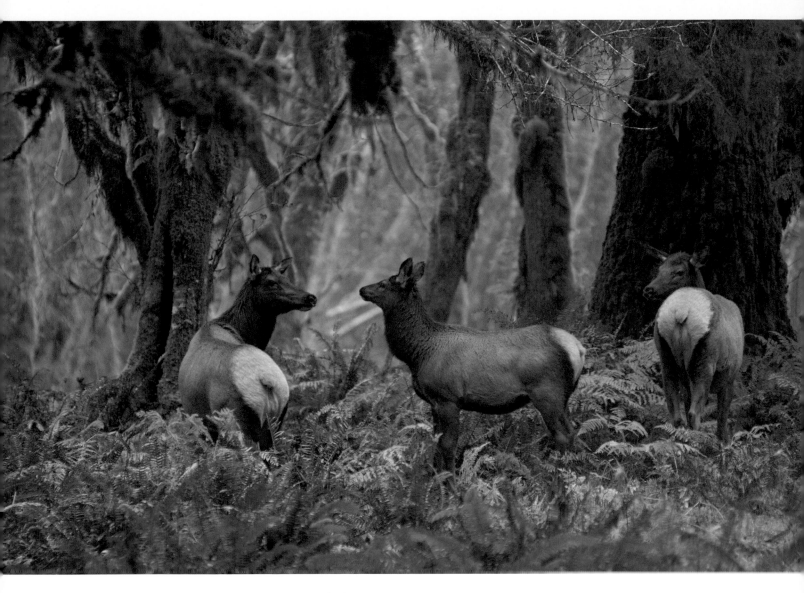

Roosevelt elk (Cervus canadensis roosevelti) *live in the lush ferns and moss of the rainforest. Olympic National Park, Washington*

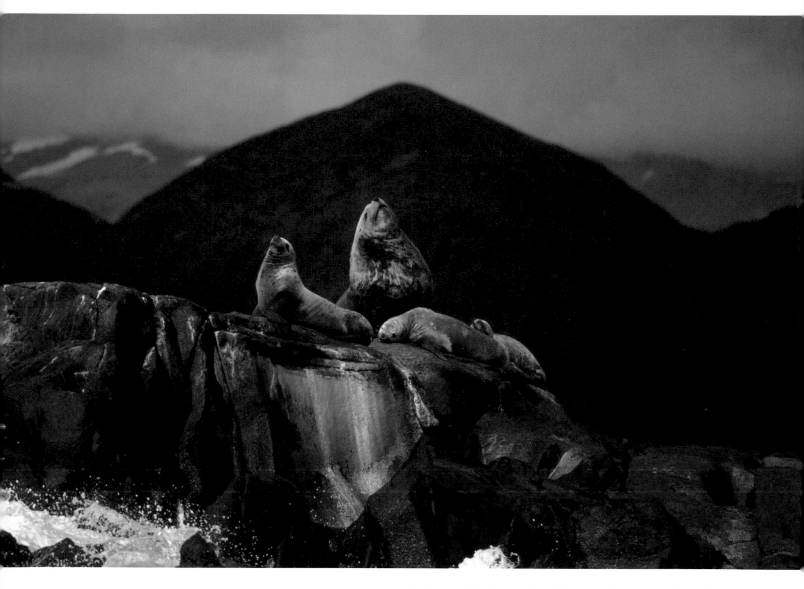

Endangered Steller sea lions (Eumetopias jubatus) sun themselves along the rocky coast. Katmai National Park, Alaska

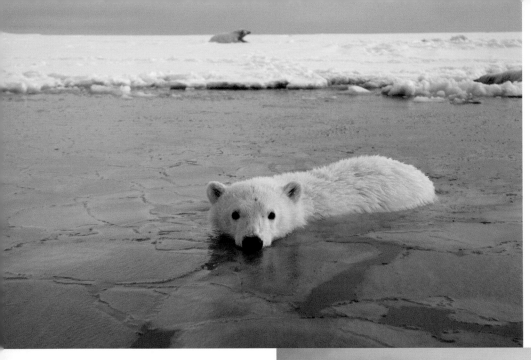

Polar bears are most often found at the edge of open leads in the polar pack ice, moving with, through, and across the ice, constantly in motion—as is the ice itself—from wind and currents.

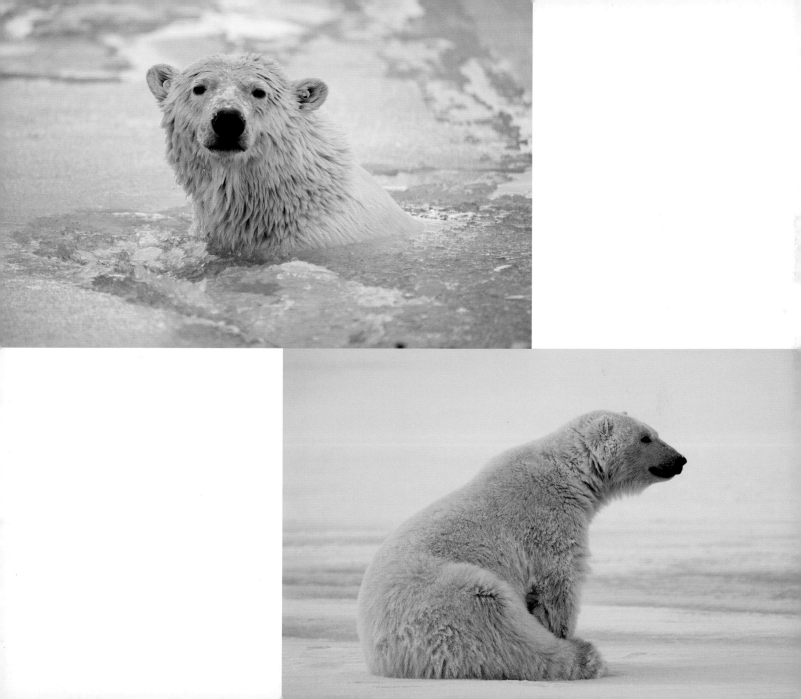

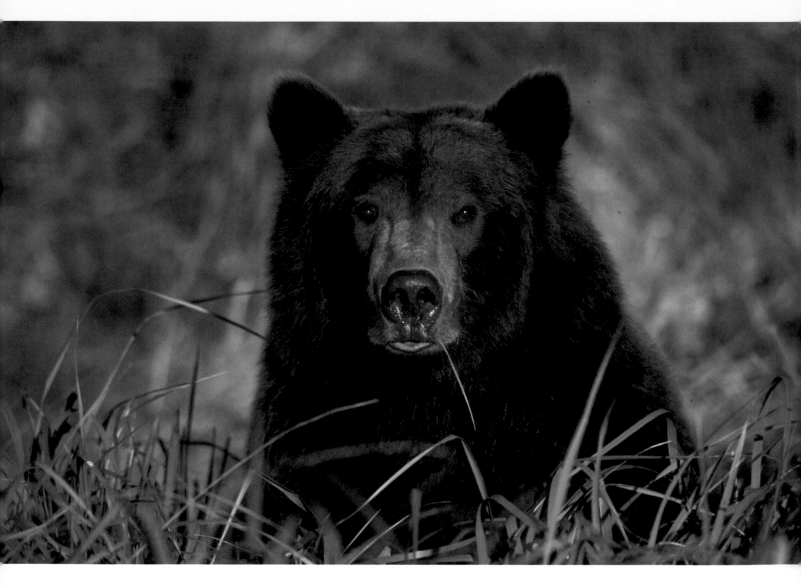

A grizzly sow feeds on lush grass. Katmai National Park, Alaska

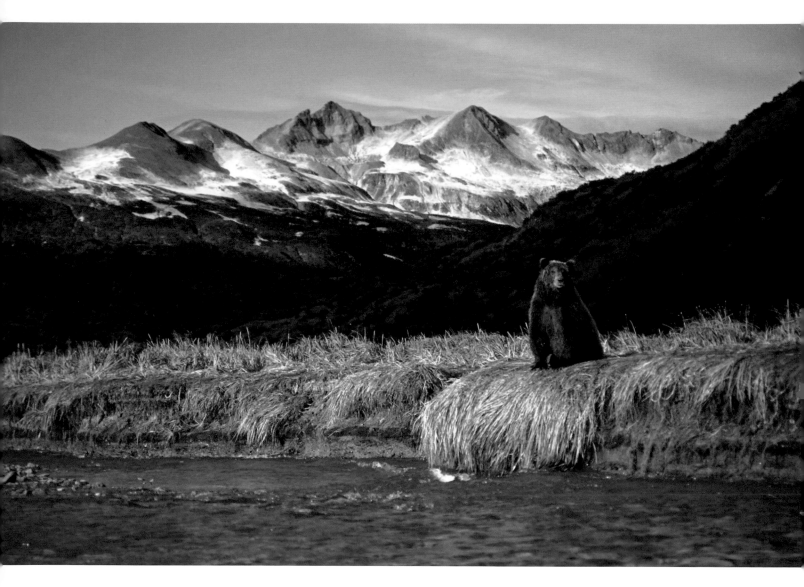

A grizzly sow takes a break from fishing.
Katmai National Park, Alaska

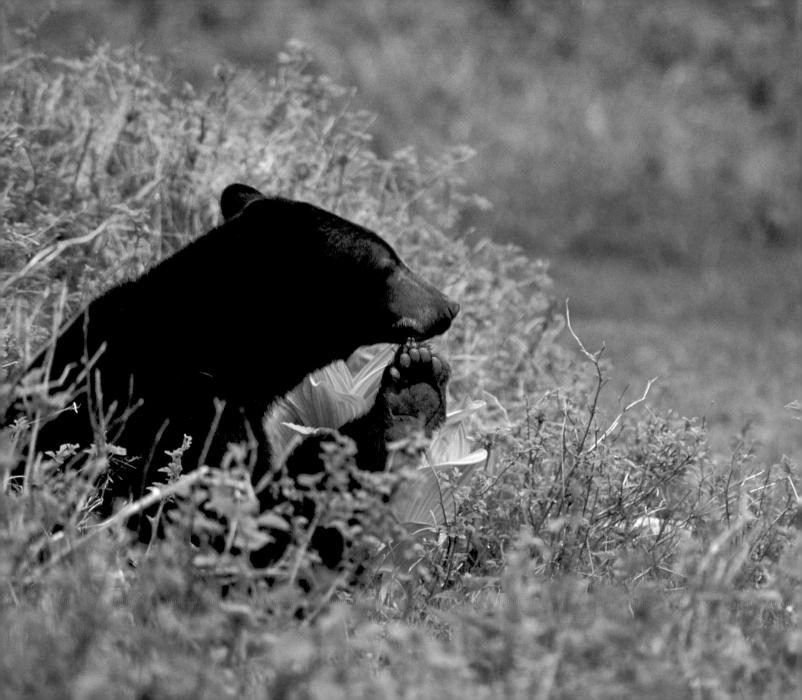

OPPOSITE *An adult black bear scratches its chin.*
THIS PAGE *Black bears that have access to salmon runs have a greater chance of making it through winter to arrive healthy and strong in spring.*

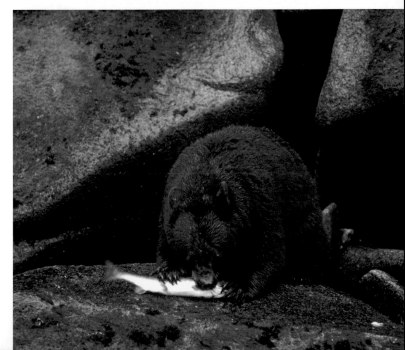

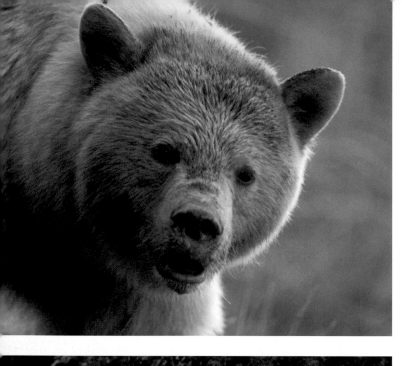
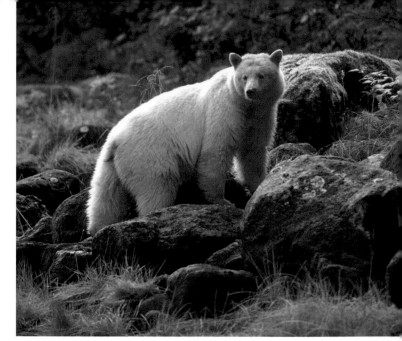
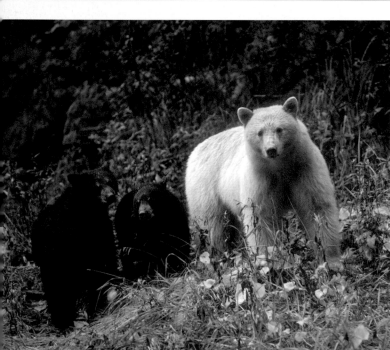
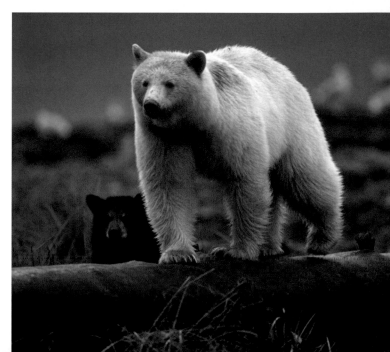

Some scientists believe the white spirit bear is more efficient at capturing salmon than its darker black bear cousins because its lighter color makes it less visible to salmon against the bright surface of the water.

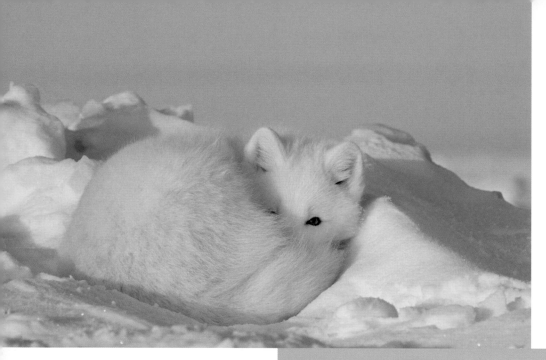

LEFT *An adult Arctic fox (Vulpes lagopus), wearing its winter coat of white, rests in a snow drift along the Arctic coast.* BELOW *An adult polar bear sow scans the horizon during fall freeze-up.*

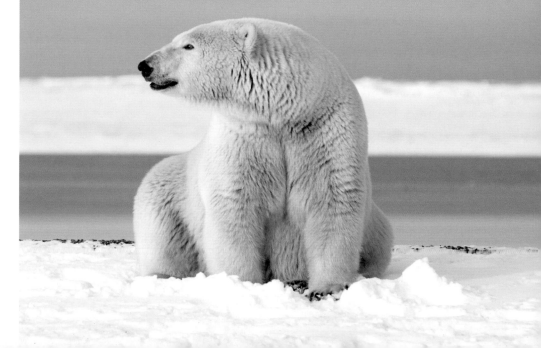

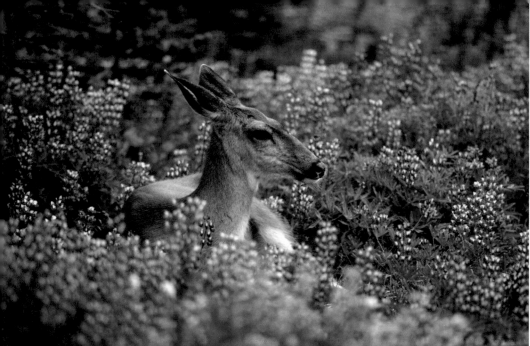

ABOUT *A Columbia blacktail deer doe (Odocoileus hemionus columbianus) rests in a meadow filled with blooming lupines.*
RIGHT *A grizzly sow rises from a nap.*

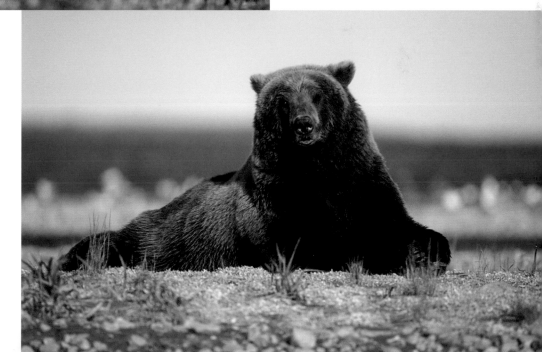

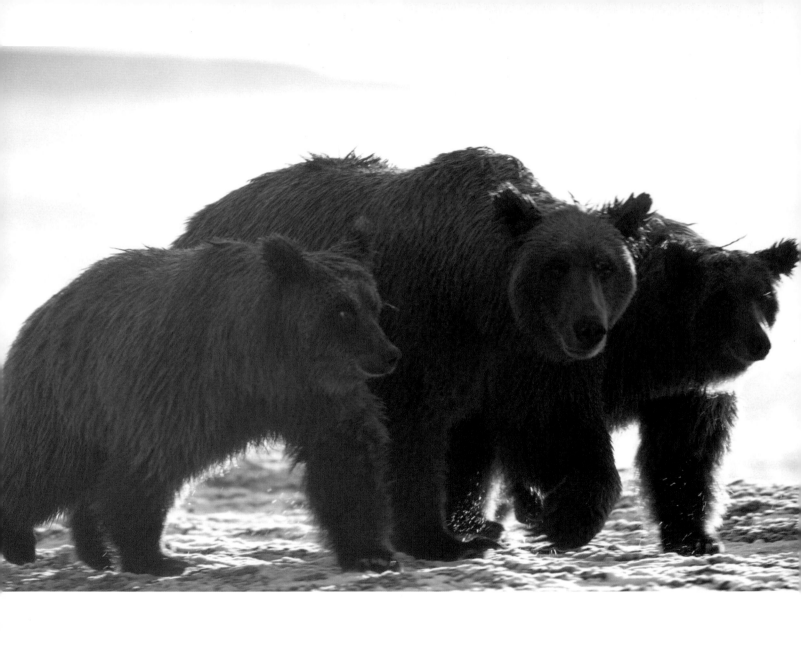

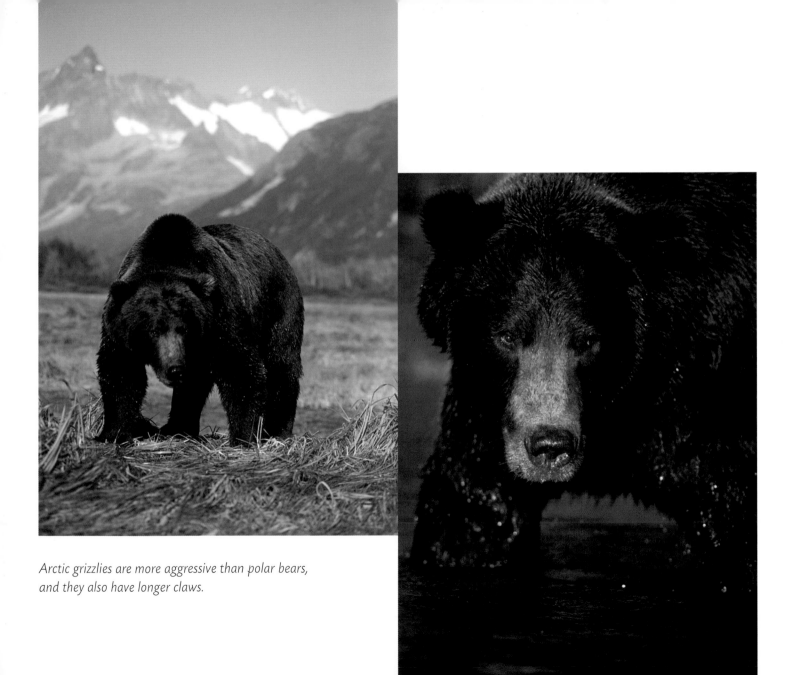

Arctic grizzlies are more aggressive than polar bears,
and they also have longer claws.

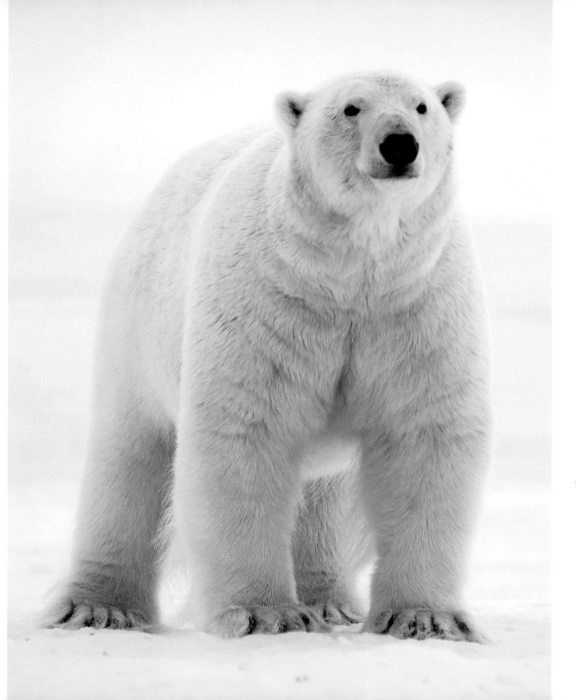

LEFT *A large male polar bear stands on pack ice.*
OPPOSITE *A curious adult polar bear peers through the window of a pickup truck.*

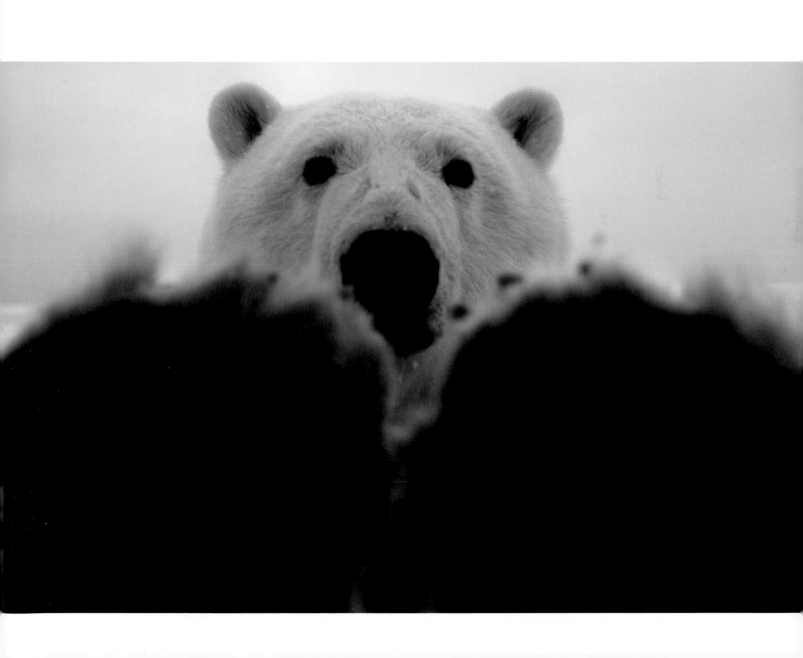

RIGHT *A spring cub plays on her mother's back during fall freeze-up.* BELOW *A radio-collared sow and her spring cubs rest on newly formed pack ice.*

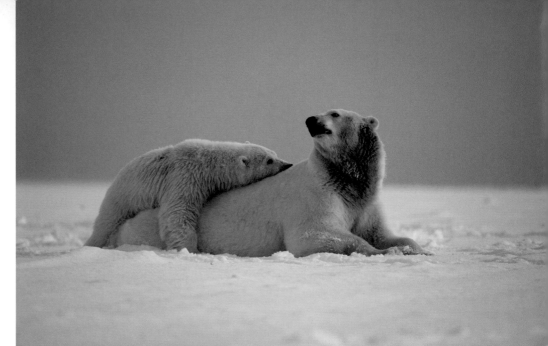

OPPOSITE *A polar bear sow favors her broken leg.*

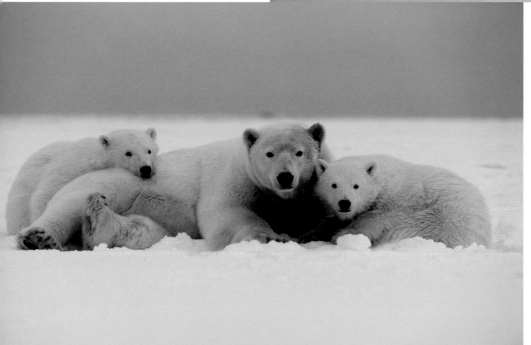

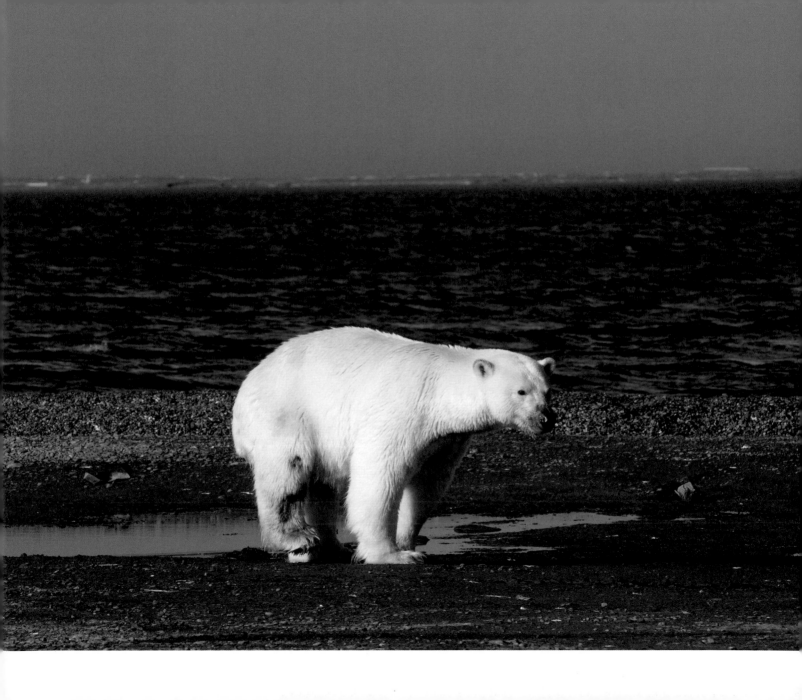

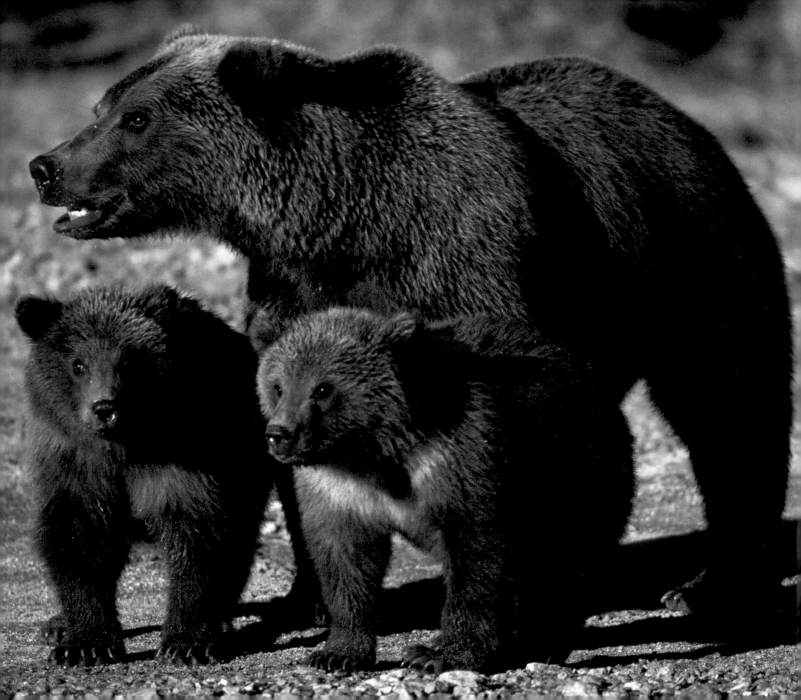

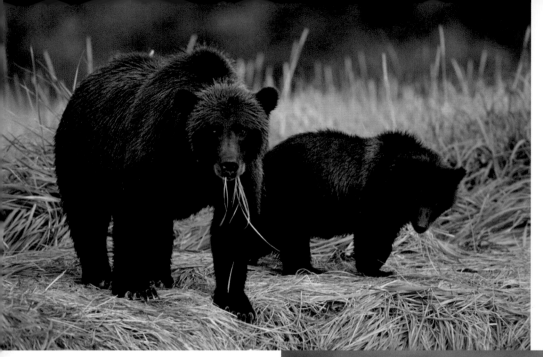

LEFT *A grizzly sow and her cub feed on tall grasses during a break from fishing.* BELOW *Spring cubs wait for their mother.*

OPPOSITE *A female grizzly and her cubs look healthy from being well fed on salmon.*

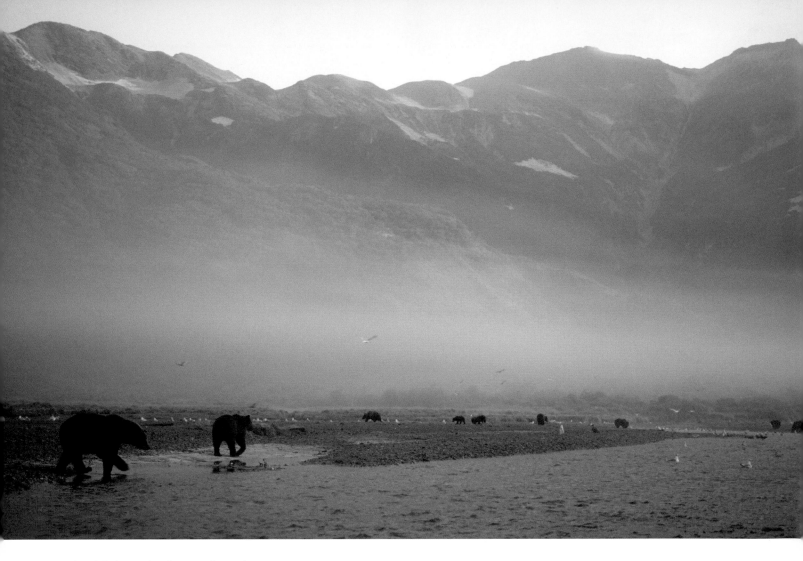

Grizzlies fish for pink salmon at low tide at sunrise.

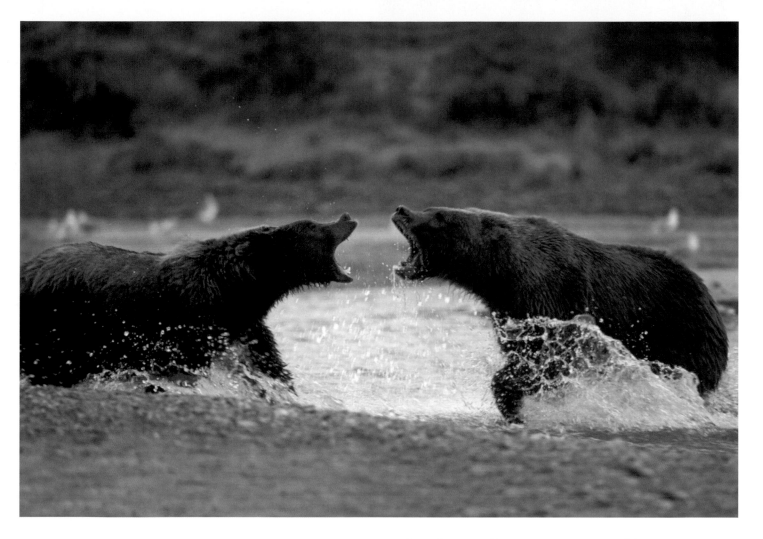

A grizzly sow and boar argue over a prime fishing spot.

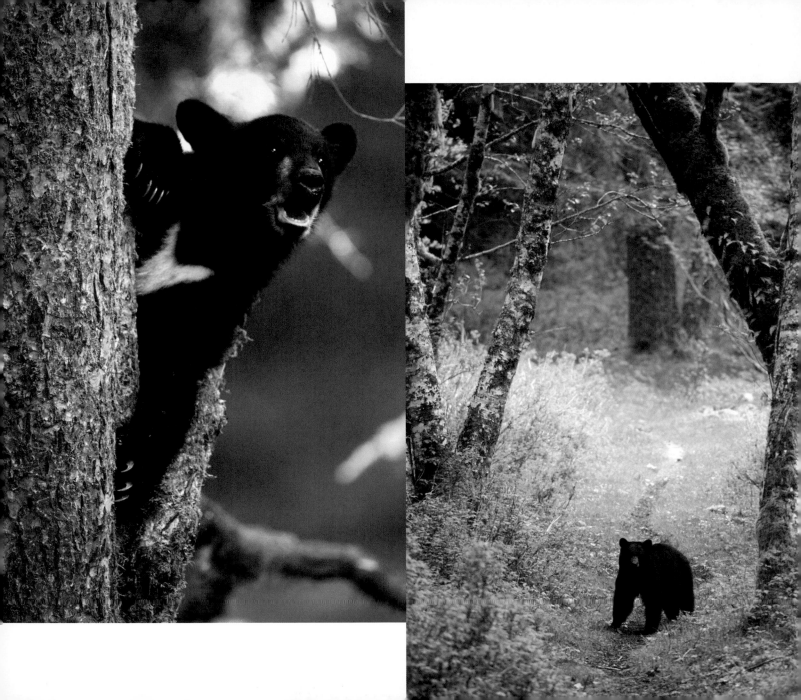

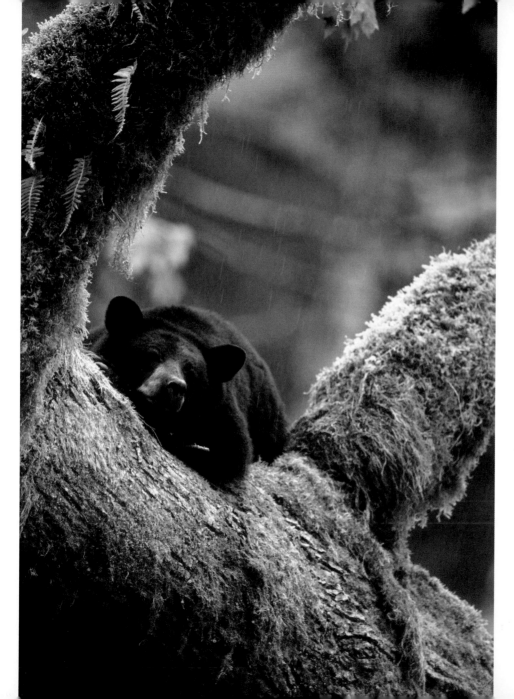

OPPOSITE, LEFT *A black bear cub, safely up a tree, calls for its mother.* OPPOSITE, RIGHT *A young adult black bear walks a trail.* LEFT *A young black bear boar rests in a moss-covered tree. Olympic National Park, Washington*

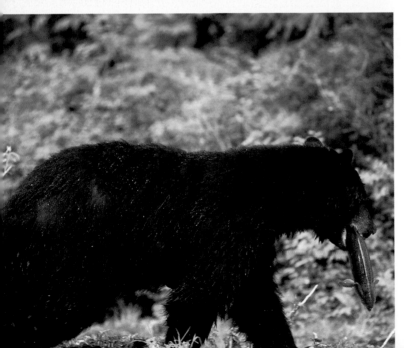

Like most bears, black bears tolerate one another only when food concentrations are plentiful.

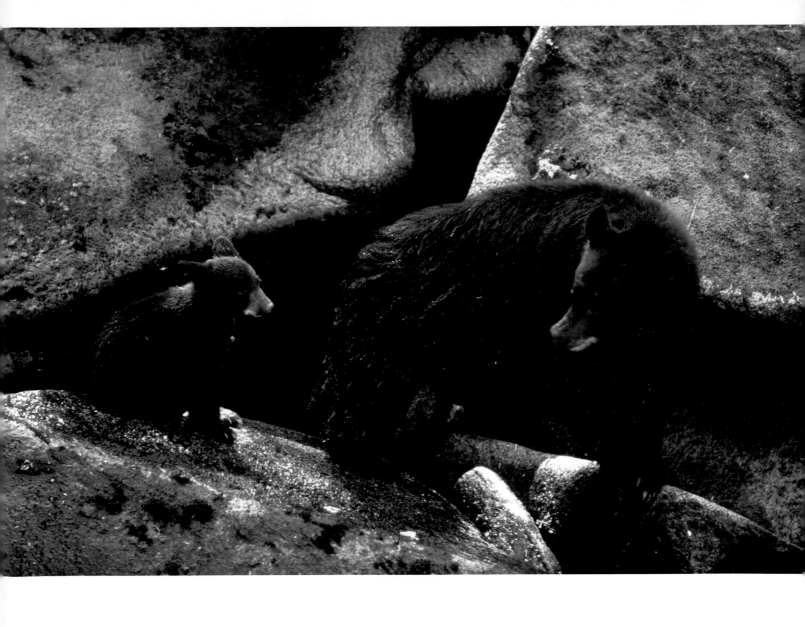

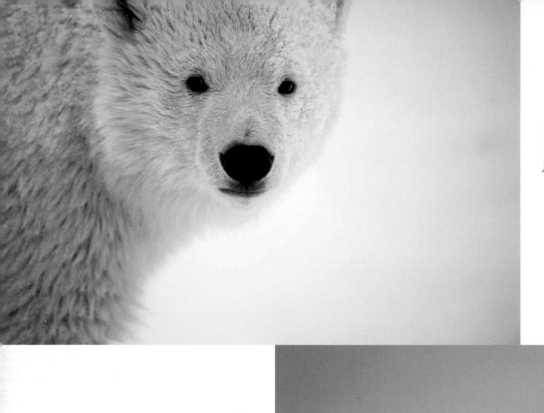

LEFT *A polar bear cub is watchful.*
BELOW *Two well-fed cubs are plump from scavenging a whale carcass.*

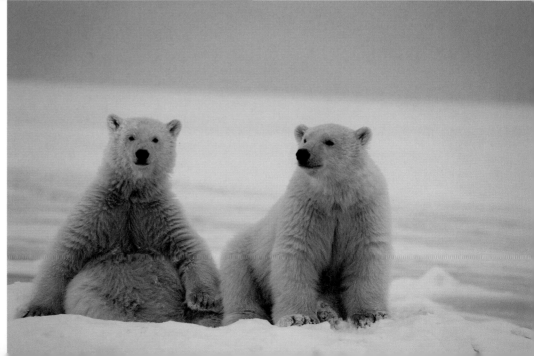

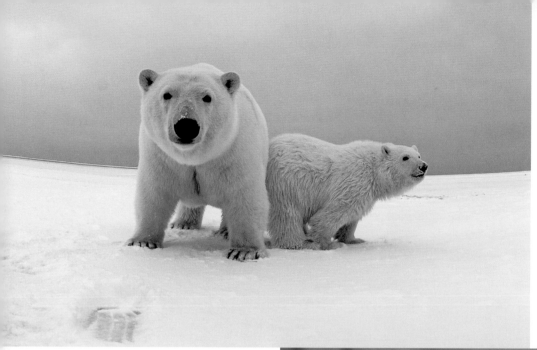

ABOVE *A sow and cub walk on pack ice.* RIGHT *An adult rolls and stretches on newly formed pack ice.*

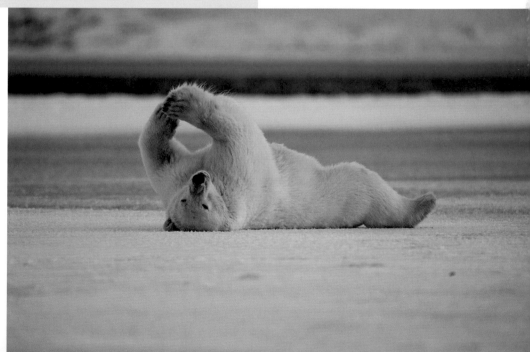

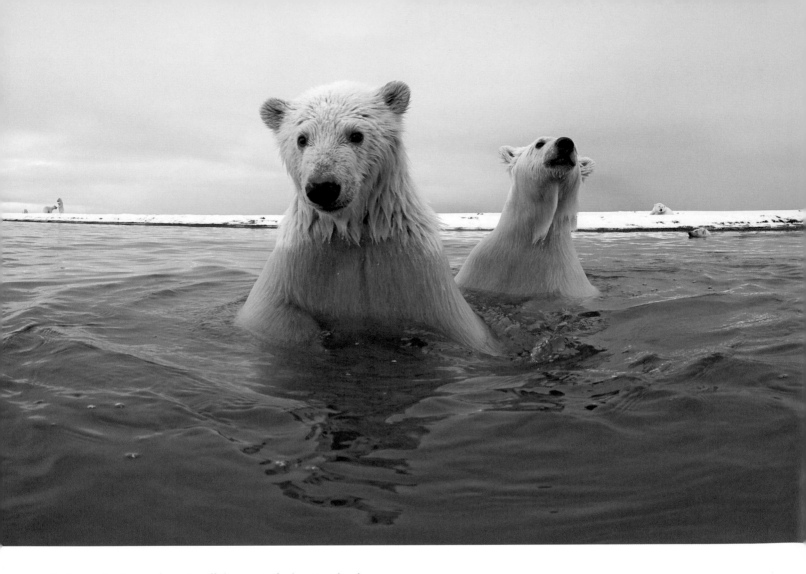

Curious polar bear cubs swim off the coast of a barrier island,
with other boars in the distance.

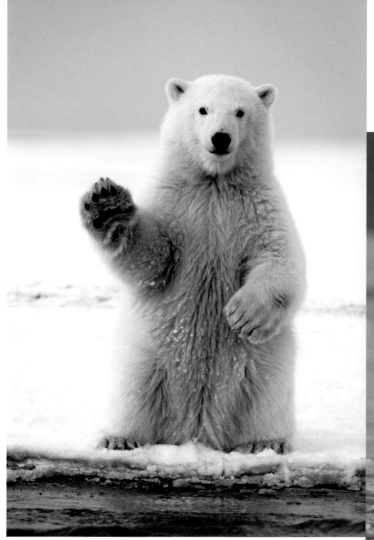

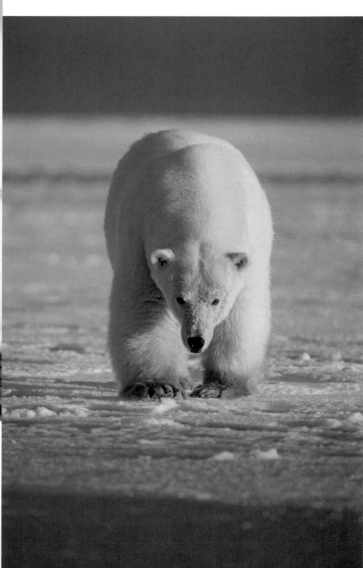

ABOVE *A polar bear cub, using its paw to balance itself on its hind legs, appears to be waving.* RIGHT *A curious young adult male approaches over the pack ice.*

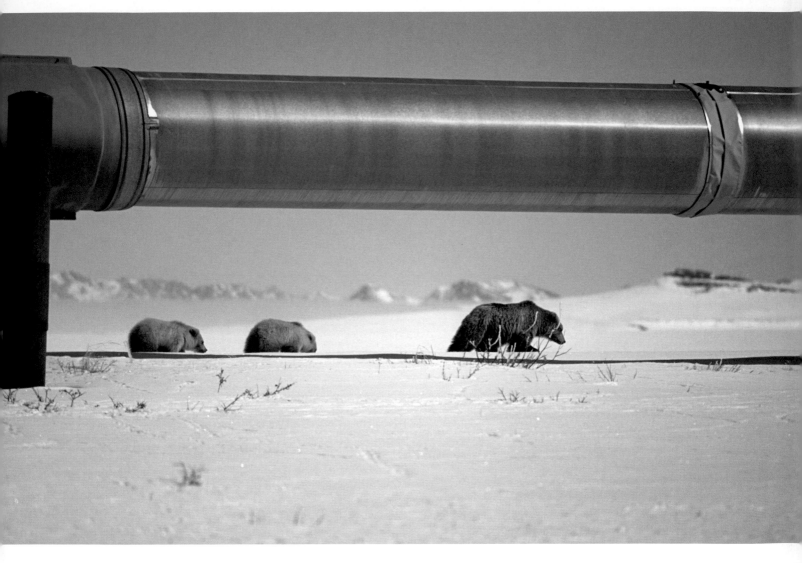

A female Arctic grizzly and her two cubs travel along the Trans-Alaska Pipeline in search of food.

OPPOSITE (CLOCKWISE FROM UPPER LEFT) *An Arctic grizzly cub sits on the tundra; a Katmai grizzly sow scratches behind her ear; a grizzly fishes for salmon in Katmai; an Arctic grizzly cub waits for its mother.*

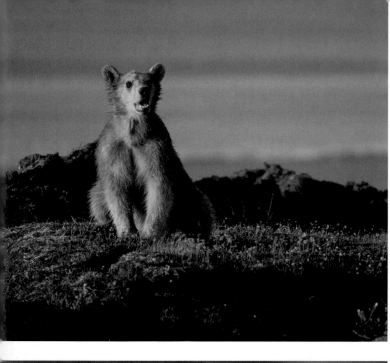
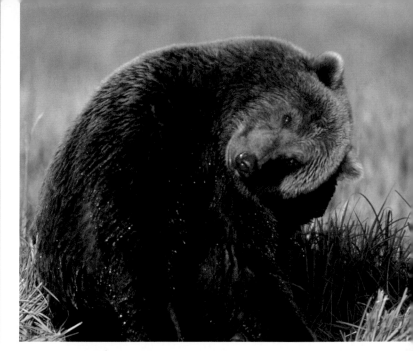
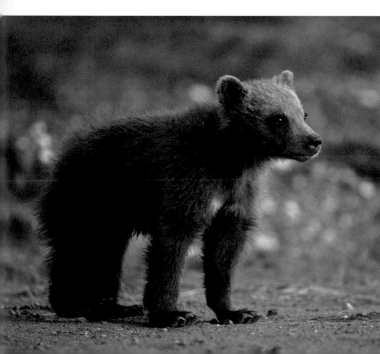
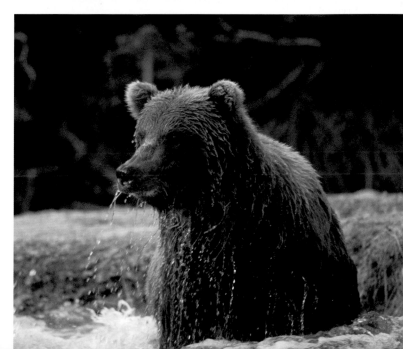

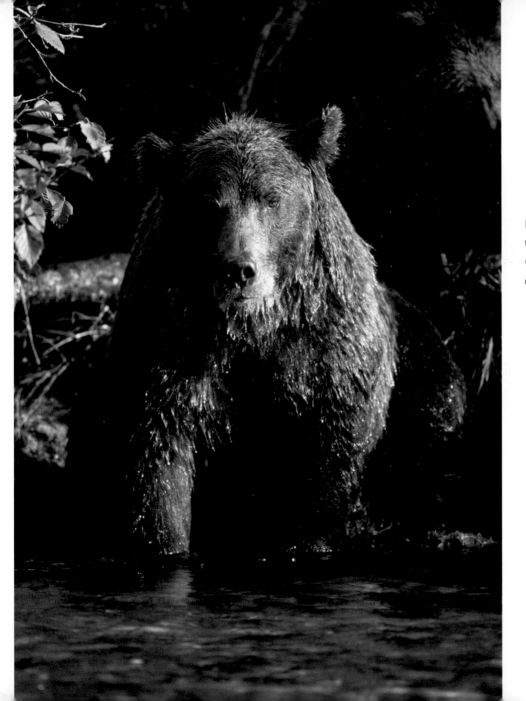

LEFT *A massive senior male grizzly watches for passing salmon.*
OPPOSITE *Spring grizzly triplets wait on a riverbank.*

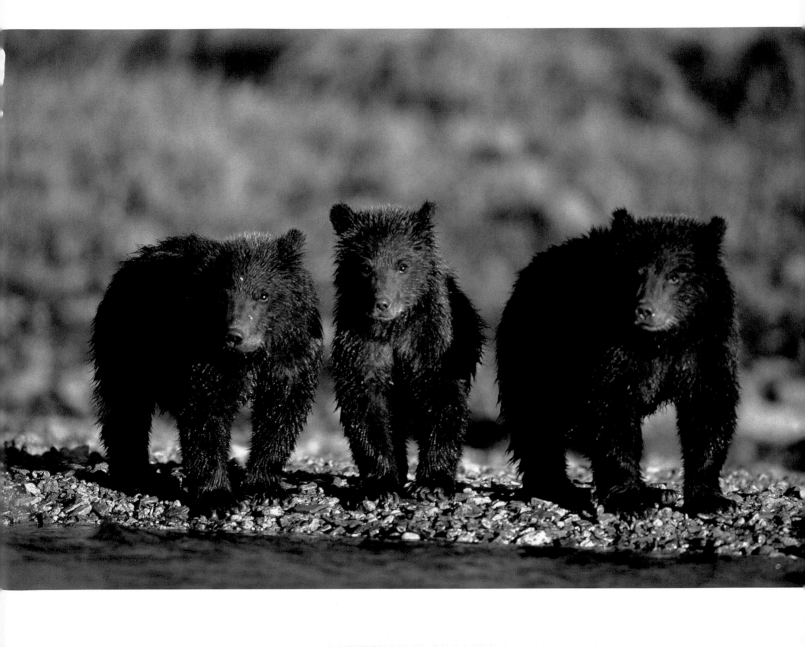

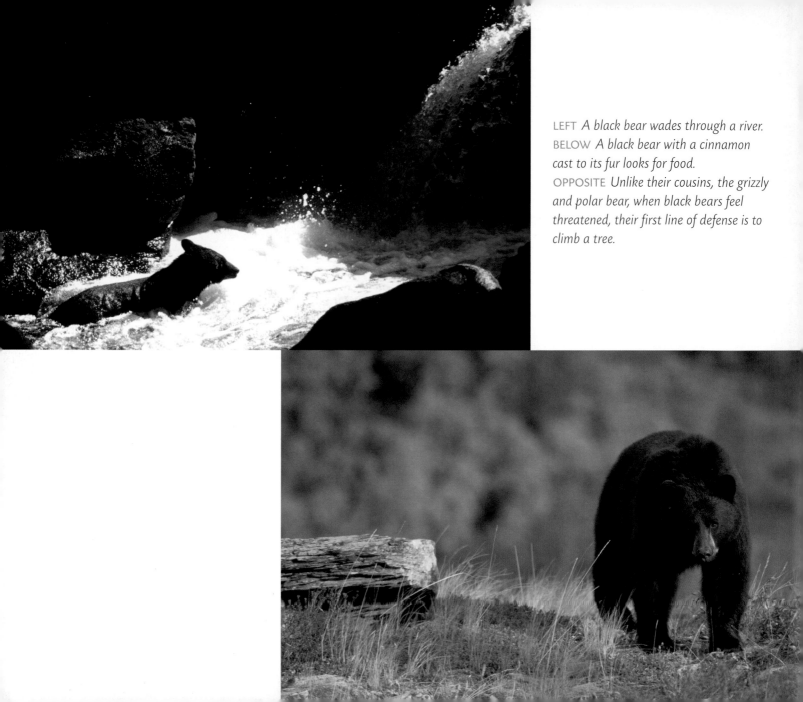

LEFT *A black bear wades through a river.*
BELOW *A black bear with a cinnamon cast to its fur looks for food.*
OPPOSITE *Unlike their cousins, the grizzly and polar bear, when black bears feel threatened, their first line of defense is to climb a tree.*

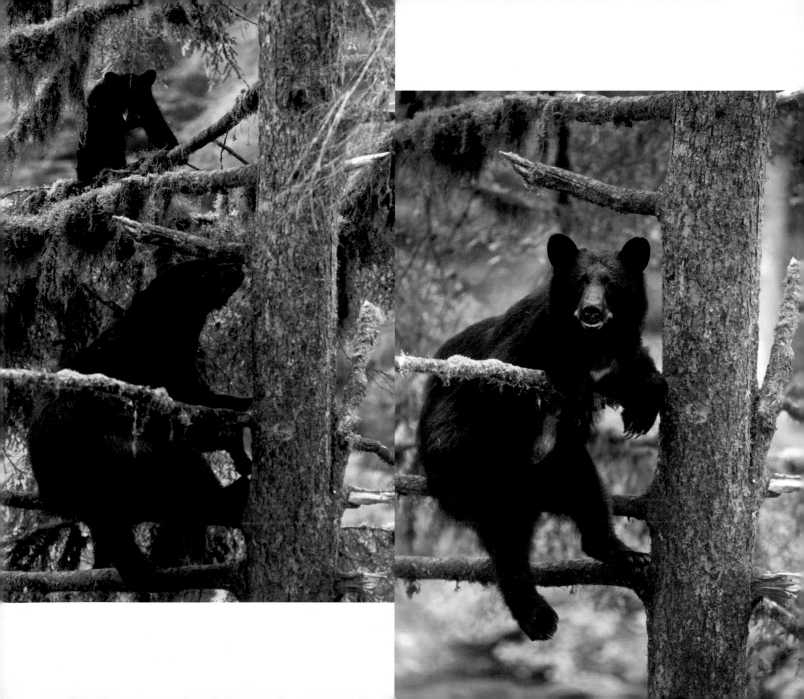

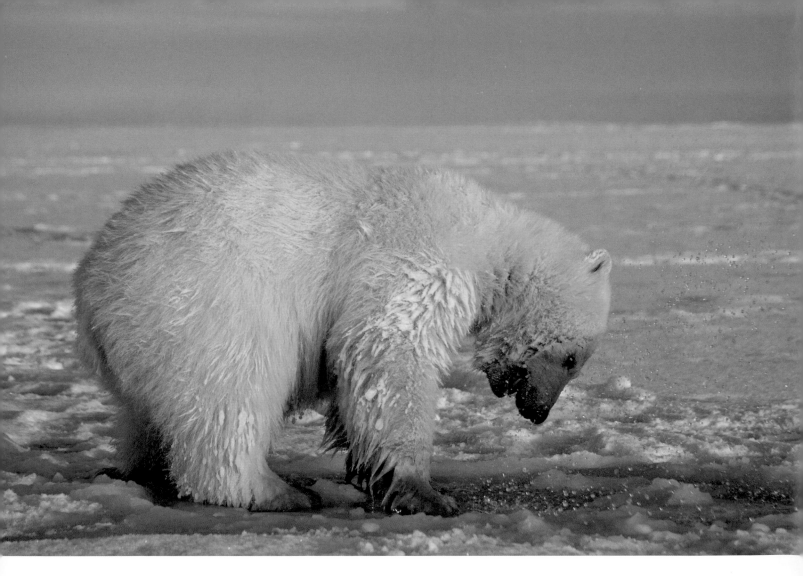

A polar bear cub practices its hunting skills.

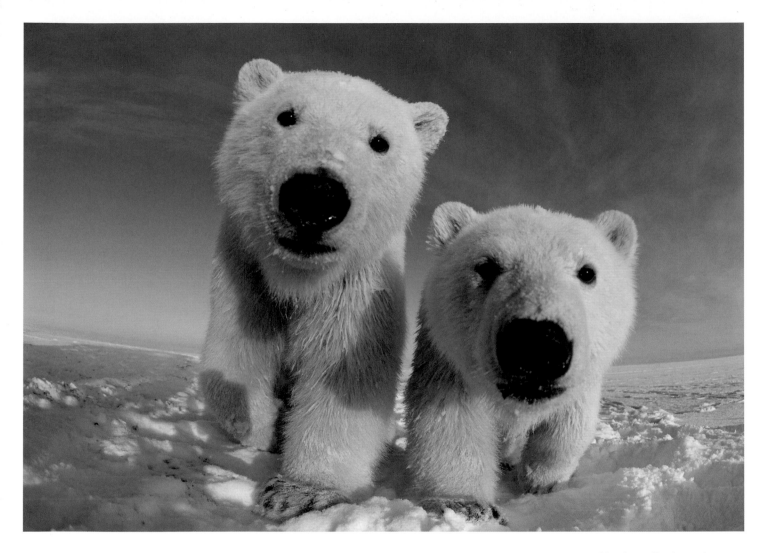

Curious two-year-old cubs walk along the Arctic coast during fall freeze-up.

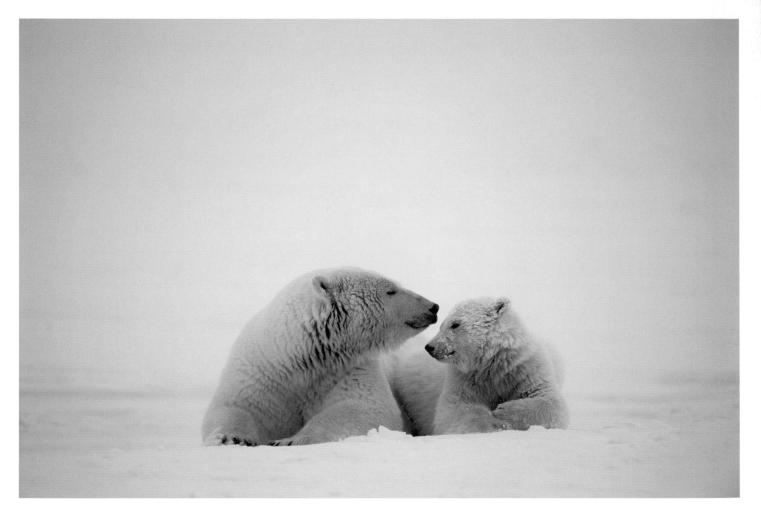

A sow nuzzles her cub as they rest.

OPPOSITE (CLOCKWISE FROM UPPER LEFT) *A polar bear sow with her spring cub; a young bear rests on the ice at sunrise; two male bears travel the ice together; a sow walks along the coast during fall freeze-up.*

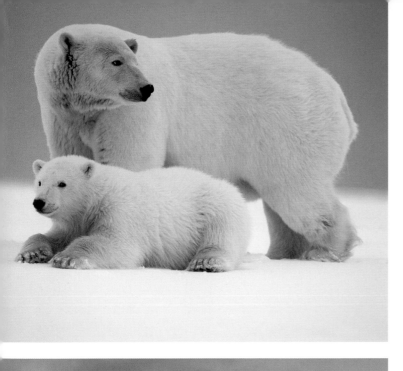
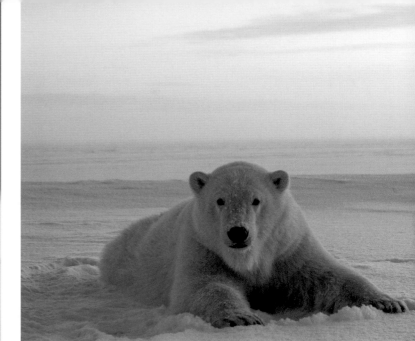
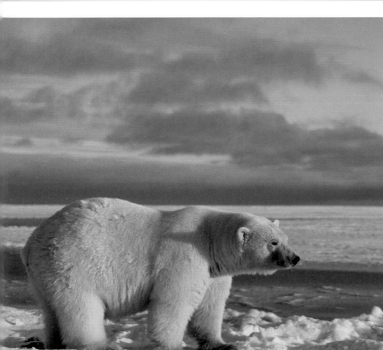
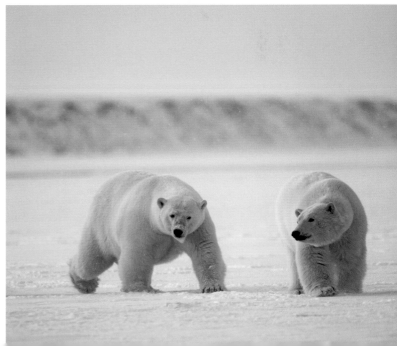

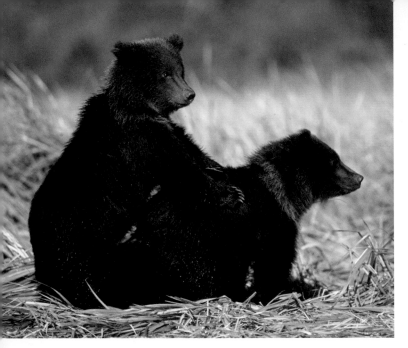

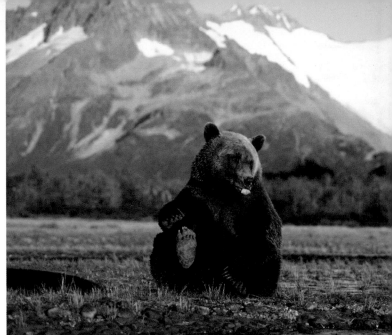

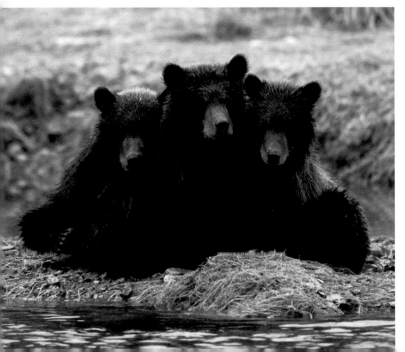

ABOVE LEFT *Spring grizzly cubs wait for their mother.*
ABOVE RIGHT *A sow rises from a nap.* LEFT *Triplet cubs nestle together while waiting for dinner.* OPPOSITE *A collared Arctic grizzly sow walks the summer tundra.*

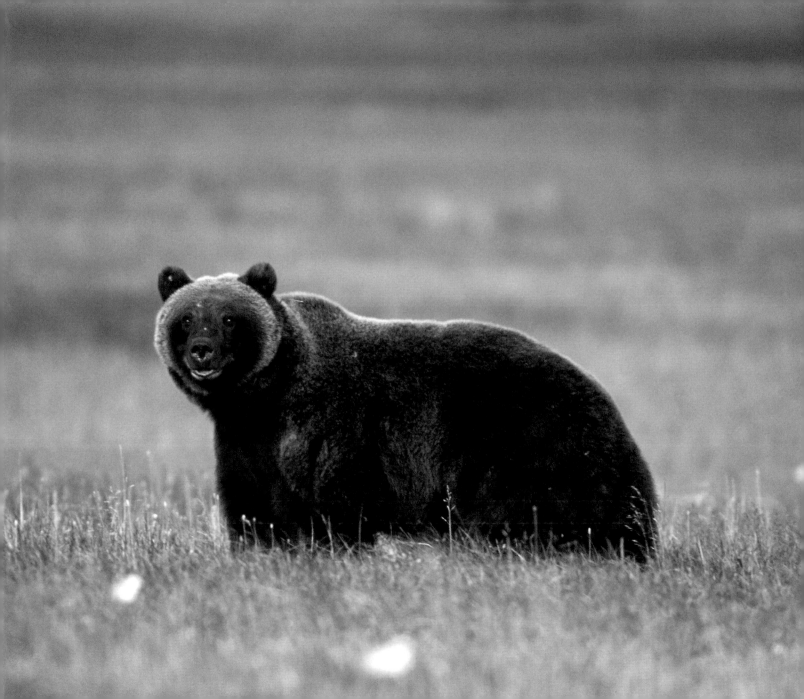

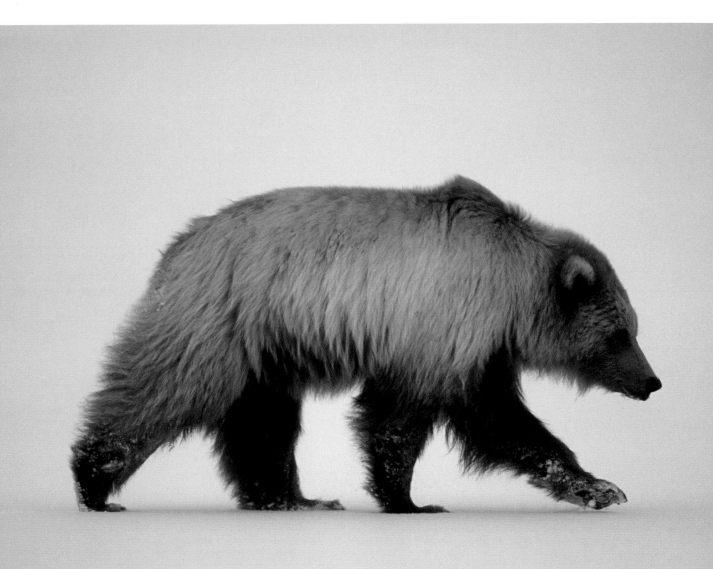

ACKNOWLEDGMENTS

To Sundra Coulson, for refining all the raw pictures and my raw thoughts at the start of the process, and for all her work in making sure all the pieces got to the right people.

To Christine Clifton-Thornton, for whom working on these projects and bringing them to a much higher level is a labor of love. Many thanks for taking my thoughts and making them into wonderful sentences that explain my stories and pictures.

To Helen Cherullo and Kate Rogers, for their dedication and joy in producing quality photographic books at a time when beloved hand-held books are disappearing off the shelves, and for their vision for the future of publishing these types of works.

To Margaret Sullivan, for the wonderful job she has done bringing all the pieces together to make a great end product. And to Jane Jeszeck, for her skill in organizing and laying out images in a way that makes them such a pleasure to look at.

Many thanks to all these folks and others who have worked as hard as I have to make this and other projects happen. I look forward to working with them again in the future.

OPPOSITE *A young adult male Arctic grizzly hunts on winter tundra.* FOLLOWING PAGE *Spring grizzly cub triplets*

Steven Kazlowski is an award-winning nature photographer whose photographs have been featured in *Audubon, BBC Wildlife, National Geographic, National Wildlife, Sierra, Newsweek, TIME,* and *Vanity Fair* magazines. He has published several books, including *Alaska Wildlife Impressions, Alaska's Bears of the North, Alaska's Wildlife of the North, The Last Polar Bear: Facing the Truth of a Warming World,* and most recently *Ice Bear: The Arctic World of Polar Bear.* He has also appeared on television programs, including ABC's Good Morning America, and has been interviewed on various NPR radio programs.

Steven earned a degree in marine biology and worked as a biologist before setting out for Alaska to pursue his true passion—wildlife photography. He now spends more than six months a year in the field. His goal is to create awareness and promote conservation of natural environments by making striking images that connect people to places and animals, telling stories through book projects as a basis for outreach and education about polar bears and arctic environments.

For more of his work, visit his website: lefteyepro.com. To view polar bears in the Alaskan Arctic, contact him at steven@lefteyepro.com.

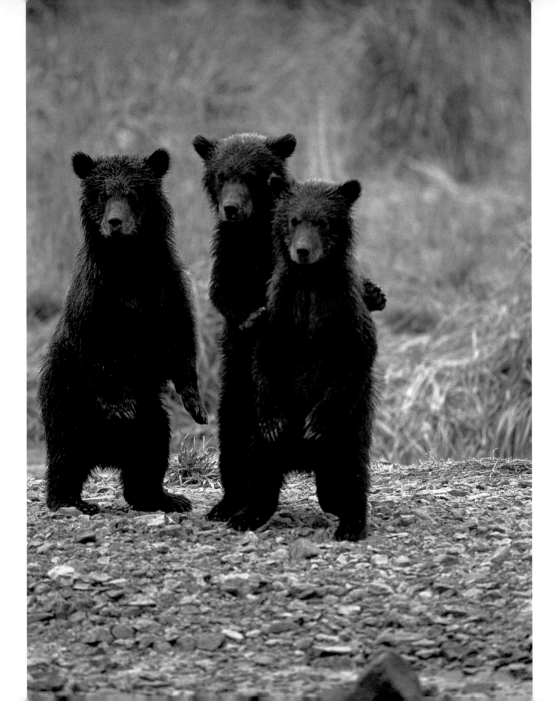